PUBLIC ART SAINT PAUL PRESENTS **THE**

WING YOUNG HUIE
UNIVERSITY AVENUE PROJECT

THE LANGUAGE OF URBANISM:

PUBLIC ART SAINT PAUL PRESENTS

THE UNIVERSITY AVENUE PROJECT

VOLUME ONE

A SIX-MILE PHOTOGRAPHIC INQUIRY

WING YOUNG HUIE

MINNESOTA HISTORICAL SOCIETY PRESS

"LATER, WHEN I SCRUTINIZED MY FATHER **THROUGH THE CAMERA LENS** **FOR THE FIRST TIME**, IT WAS STRANGE AND EXHILARATING. I WAS LOOKING INTENTLY AT SOMEONE FAMILIAR AND SEEING SOMETHING NEW."

MY FATHER WAS my first photographic subject. I was twenty, a sophomore in college and living at home, when I made those initial exposures of him in the kitchen with my first camera. He was eighty-three, enjoying his retirement after a lifetime of hard labor. He had worked his way up from a non-English-speaking, illegal teenage immigrant to a successful restaurateur in Duluth, Minnesota.

I was lucky. My father didn't want my oldest brothers to go to college; he said he needed them to work in the family business. But as the youngest of six—and the only one in my family not born in Guangdong, China— I was given the luxury of choosing my own future. Although I didn't know it then, I was already headed on a path toward becoming a self-indulgent artist.

I rarely saw my father at home. He worked twelve-hour days, seven days a week. I didn't really talk to him much until I started working at Joe Huie's Café at the age of twelve. Under my father's watchful eye, I carefully filled in the business ledgers by hand, waited on tables, and did side work in the kitchen. Later, when I scrutinized my father through the camera lens for the first time, it was strange and exhilarating. I was looking intently at someone familiar, and seeing something new.

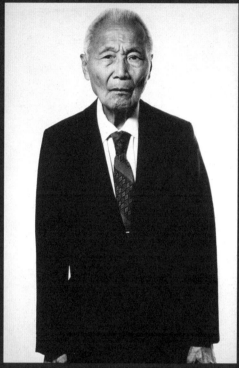

Joe Huie

5

In a way it was the most intimate experience I ever had with my father, whose cultural references were quite foreign to me, the Minnesota-born and -bred son who had never even been to China. When I was a kid, every Chinese New Year, my mom would make me repeat after her a prayer to Buddha in Chinese. But it was Jesus Christ Superstar that eventually spoke to me as I became a Jesus freak in my early teens. There was so little in American popular culture of the 1960s and 1970s that mirrored my family that at times my own parents seemed exotic to me.

I don't think I was conscious of this at the time, but I now realize that those initial photos of my father in the kitchen were my first steps in creating a new cultural iconography, to counter the myths and images that had formed me. Several years later those kitchen photos were printed in *Lake Superior Port Cities* magazine, accompanying an article that I had written about my father. It was my first published work. I had recently graduated from the University of Minnesota, armed with a B.A. in print journalism and a budding, self-taught proficiency in photography. Now, some thirty years and hundreds of thousands of exposures later, I'm still trying to look at the world anew, making photographic sense of the familiar and unfamiliar.

The University Avenue Project brings me full circle. In 1995, when I was forty, I had my first solo exhibition in a grassy lot in Frogtown, a central St. Paul neighborhood connected to the rest of the city by University Avenue. I wanted to put the photographs in a public space so that more people could see them. Although I had never seen an outdoor photography exhibit, I was intrigued by the idea and curious about what might happen.

I pinned almost two hundred photographs (all eleven by fourteen inches) onto four-by-eight-foot sheets of Styrofoam that were shrink-wrapped in clear plastic, framed in wood, and attached to metal fence posts anchored in the ground. Those gleaming white panels, which contained the reflected photographic bits of hundreds of Frogtown realities, stood in a space previously occupied by a porn bookstore. The exhibition, *Frogtown: Portrait of a Neighborhood,* instantly became a newly formed communal locus, commingling folks from the area with those from other neighborhoods and surrounding suburbs, many of whom would normally have been reluctant to come into the urban core.

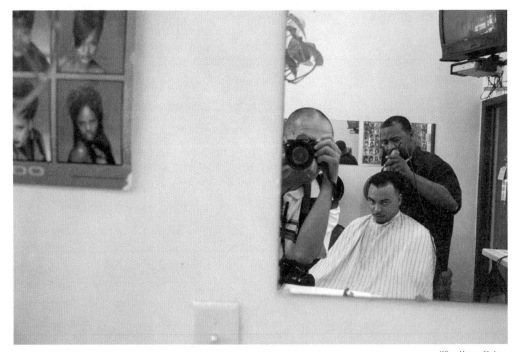

Wing Young Huie

The experience brought to mind these words from Boris Pasternak's novel *Doctor Zhivago:*

> . . . [C]ities are the only source of inspiration for
> a new, truly modern art . . . The living language of
> our time, born spontaneously and naturally in
> accord with its spirit, is the language of urbanism
> . . . The city, incessantly moving and roaring
> outside our doors and windows, is an immense
> introduction to the life of each of us.

What initially drew me to Frogtown were the area's burgeoning Southeast Asian communities, of which the Hmong make up the majority. At that time, Hmong immigrants and Hmong Americans comprised a quarter of the population in the neighborhood. I was curious to discover how the uprooted Hmong reflected my own family's experience. I would see an elderly Hmong woman on the street who looked as though a part of her remained in the jungles of Laos, and I would think of my mother, who had rarely left our house in Duluth and never learned to speak English.

I could also see myself reflected in the younger Hmong who were becoming acculturated, Americanized. Both the cultural gulf between that first generation and their immigrant parents and the complexities of being a hyphenated Minnesotan in the land of Lake Wobegon were things I wanted to explore and understand.

A couple of years later I expanded the concept I'd worked with in Frogtown, spending four years photographing Lake Street, a well-known Minneapolis thoroughfare that connects the trendiest enclaves to the poorest areas in the city. In 2000, with the help of dozens of volunteers and the support of community organizations and museums, Lake Street was transformed into a six-mile gallery of nearly seven hundred photographs displayed in store windows, at bus stops, on the sides of buses and buildings. The images ranged in size from eight by ten inches to eight by twelve feet.

It is impossible to know how many saw the work intentionally, and it is difficult to gauge how it impacted unwitting viewers. But for six months, if you were in a car or bus, on a bicycle or skateboard, or on foot somewhere along the avenue, the photographs of *Lake Street USA* were difficult to avoid. Much has been written analyzing the exhibit and its impact, but how do you really know what happens when you reveal thousands of private lives in such a public manner?

The remark that sticks with me was from a young woman. Normally, she told me, when she drives or walks down the avenue and spies something or someone compelling, she averts her eyes out of politeness, or discomfort. "Your photographs," she said, "give me a chance to stare. And staring leads to knowing." After Lake Street I didn't think I would attempt such a large-scale project again. Not only was it exhausting, but it didn't fit into the long list of small, varied concepts and subjects I wanted to pursue. Yet one of those smaller projects led me to University Avenue.

In 2006, I was asked by Coen + Partners, a well-regarded landscape architecture firm, to help redesign Dickerman Park. The job was to turn this small tract of land, stretching

along University Avenue between Fairview Avenue and Aldine Street in St. Paul, into a photo-driven plaza, scheduled for completion in 2014.

Christine Podas-Larson, the president of Public Art Saint Paul, was also involved in the Dickerman Park redesign. She urged me to think about doing a larger project on University Avenue, which was likely to be transformed in the near future by a planned light rail line connecting downtown Minneapolis to downtown St. Paul. This might be the last chance to document the neighborhoods along the central corridor before a billion-dollar mass transit project impacted the area in ways difficult to predict.

My ideas about photography had evolved over the years, but I wondered how I could do something that would seem fresh and not a *Lake Street USA* redux. I had been mixing color and black-and-white photographs in recent projects, so color would surely be a part of *The University Avenue Project*. I had also been shifting away from a classic documentary style that tends to exoticize subjects. For University Avenue, I hoped to capture not the exotic or dramatic, but the normal everyday of people living. I wanted to pursue an aesthetic that was hopefully less voyeuristic, deflating the distance between viewer and subject.

"HOW DO YOU REALLY KNOW WHAT HAPPENS WHEN YOU REVEAL THOUSANDS OF PRIVATE LIVES IN SUCH A PUBLIC MANNER?"

I had all of that in mind when Christine called me with news of a special award program of the Joyce Foundation that would provide support for new works by artists of color. She suggested that Public Art Saint Paul commission me to work on the project. We applied for and received word of the award in the fall of 2007. Soon after, I started photographing the neighborhoods connected by University Avenue.

While there are many parallels between University Avenue in St. Paul and Lake Street in Minneapolis, University has its own unique mix. From Old World to developing world to modern world, this jammed stretch of storefronts, big-box retailers, blue-collar neighbor-hoods, and burgeoning condominium enclaves—in the midst of one of the most diverse concentrations of international immigrants in the country—reflects the colliding human kaleidoscope of the evolving American experience.

WITH *THE UNIVERSITY AVENUE PROJECT,* I incorporated some new conceptual approaches, but much of the process of finding subjects has remained the same since I first photographed my father and the neighborhood where I grew up in Duluth. I simply walk around and ask people if I may take their picture. My camera opens doors, and I meander through nooks, alleys, and living rooms. For this project, I identified myself as a professional photographer doing a community-based photography exhibit where images would be publicly displayed, viewable from the street and sidewalks, along University Avenue.

Many of the people I've approached say no, but there are always those who are willing to be photographed. I have interacted with thousands of citizens who live, work, play, and worship in the neighborhoods connected by University Avenue, a stretch of six miles from the Minnesota State Capitol on the east to Emerald Street on the west where St. Paul officially meets Minneapolis.

I've photographed businesses, community organizations, and nonprofits. And for this project, I also photographed hundreds of students. This was a conscious break from the past but also a reflection of University Avenue itself. Along the avenue, I found nine schools catering to different age groups and collectively constituting amazing diversity. These schools range from AGAPE High School,

where all of the students are mothers or mothers-to-be, to the Hubbs Center for Lifelong Learning, an adult education center where over fifty countries are represented. I met with young children at New Spirit, a charter school with a large Hmong population, and Dugsi Academy, where almost all of the students are East African. At Gordon Parks High School, an alternative school named after the great multi-talented artist who began his photographic career in St. Paul, I photographed a diverse group of young people who were starting on their own paths through life.

In many of my projects I have used direct quotations to accompany the images, excerpted from interviews I conducted with people in the photos. In this volume, you'll find several short essays or portraits, sprinkled with quotations from the people I met and photographed. But with this project, I also decided to incorporate words directly into many of the photographs. I came up with a series of questions that would not be easy to answer, but might elicit a wide range of responses:

What are you? Describe yourself in a couple of sentences.
How do you think others see you? What don't they see?
What advice would you give a stranger?
What is your favorite word?
Describe an incident that changed you.
How has race affected you?

From the answers each person gave, I chose one. Rather than placing the words next to the image in an exhibition or book, I asked the participant to write the words on handheld chalkboards I made. I tried the idea at one school, tentatively at first, but then I just kept going, approaching hundreds of people in more schools, on the street, in community centers, at businesses, and at the capitol.

My process varied depending on the situation. Sometimes the interaction I had before photographing the person was brief. If the person were at a bus stop, for instance, I might ask only one or two questions. Sometimes the respondent wasn't interested in the questions and wrote what he or she wanted instead.

If there were more time, I would try to probe as deeply as I could by asking further questions. Sometimes a teacher would make answering the questions a written assignment for an entire class, and I would have pages of answers from each student to choose from. In other cases, I would ask a student to approach another student in the school—someone outside his or her social group. I would then ask the two students to interview each other and pick the answers to write on each others' chalkboard.

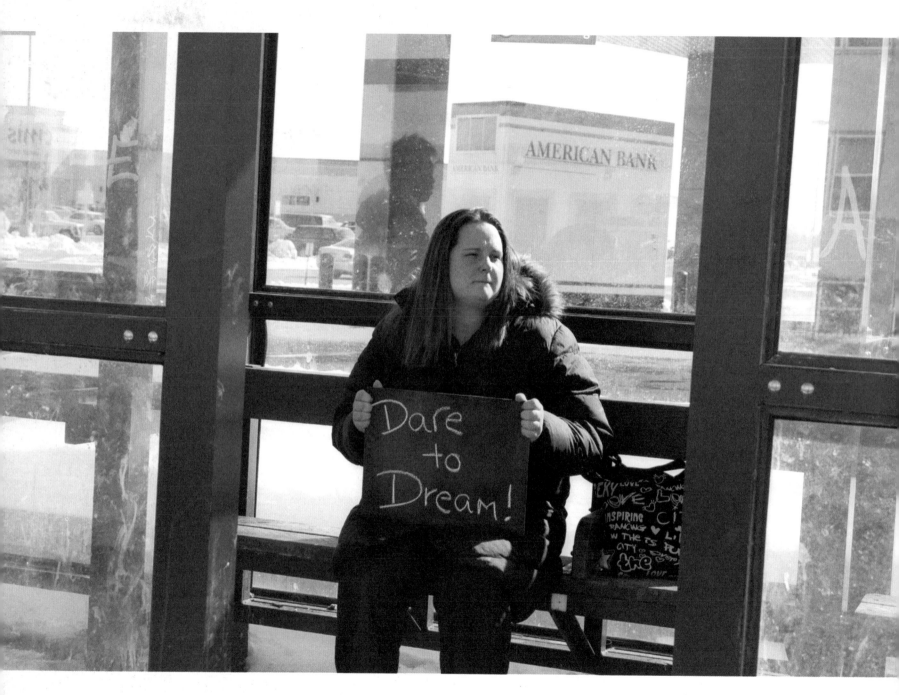

Whenever I had several answers to choose from, I would pick the one that jumped out at me, not unlike when I'm photographing and press the shutter reactively without too much thought. Sometimes, though, the person didn't like the answer I picked and would write something else. Always, I would encourage participants to be as "real" as possible and to give an answer that was personal and revealing.

It's a strange thing I imagine to have someone come up to you out of the blue claiming to be a professional photographer and wanting to extract something personal from you for public consumption. Part of me expects people to comply and another part is always a bit surprised when they say yes. What I do is intrusive, after all.

"MY CAMERA OPENS DOORS, AND I MEANDER THROUGH NOOKS, ALLEYS, AND LIVING ROOMS."

At International Academy—LEAP, a high school where all the students are immigrants and many are refugees, a teacher had several classes of students write down in journals their responses to my chalkboard questions. What they wrote about the hardships of refugee internment camps, family tragedies, and acculturation challenges was unflinchingly honest. Yet it was mixed with hopefulness about their education and future. As I read through the journals in the classroom, deciding on the spot which answers I wanted the students to write in chalk, I had to turn away at times to hide my tears.

I am not that outgoing, a bit of an introvert actually. In my personal life I would never approach thousands of people and try to draw out the stories of their lives. But this kind of interaction gets me out of my own bubble and compels me to be in the world in a way that would not happen without my camera. I have a lot of biases and stereotypes that I carry, but when I'm working I'm better able to put those aside. In that sense I'm a better person when I'm photographing.

It's difficult to sum up what I've learned from all this. Sometimes I'm asked, "What is the purpose of what you do?" I'm never sure how to answer.

Making those first photographs of my dad brought me
closer to someone not easily knowable. Maybe that's
the reason I photograph people today.

I am writing this essay more than three months before
The University Avenue Project exhibition actually opens.
I am still photographing, still meeting new people and
new challenges, and still choosing images to go on
display. For six months, from May 1 through October 31,
2010, on store walls and bus shelters and projected
onto an outdoor screen, four hundred photographs
will line the avenue. Whether people intend to or not,
thousands will see *The University Avenue Project*.

There are no doubt many ways in which University
Avenue will differ from my previous works—in con-
ception, execution, and impact—but I won't know for
sure until the exhibit opens. I plan to describe some
of those differences later. What you see on the pages
that follow is merely University Avenue, Volume I.
Stay tuned for Volume 2. . .

Wing Young Huie

THE SPARK FOR *The University Avenue Project* was struck when a circle of community partners joined forces in 2006. Our goal was to renew Dickerman Park, the only park to be found on the entire length of University Avenue in St. Paul. Dickerman Park was long unseen and obscured, considered a parking lot by some and treated as private property by others. We wanted to shed light upon its existence and its promise. Together we envisioned a vital community place of green and gardens . . . and art . . . along the expansive thoroughfare.

Landscape architects from Coen + Partners brought Wing Young Huie to the park design team. He would be creating photographs for an outdoor gallery of neighborhood residents within this remarkable strolling park. For a year, Wing met and photographed people in the immediate area, near the intersection of Fairview and University avenues. His photographs captured people in their homes, in shops and cafes, and as they walked along the street.

All the while Wing and I talked about University Avenue—its larger overall scope and how it might fit into ideas for his next big Lake Street USA–scale project. In early 2007 a flyer arrived announcing the Joyce Foundation Award, which offered a $50,000 grant to commission new work to resonate with diverse urban audiences. Wing and Public Art Saint Paul were ready. He had a bold and expansive idea that we were glad to sponsor, and here was the funding that could get it started. The Foundation's Michelle Boone was tremendously moved and inspired by Wing's work. It was with heartfelt joy that she called with news of our award.

For three years, Wing has placed himself in the midst of the dizzying pace of University Avenue. At the same time, Public Art Saint Paul has placed itself in the midst of the often dizzying dynamic of Wing's creative process. We have kept faith with each other throughout.

What was proposed in 2007 as a six-mile series of twelve slide shows in store windows has exploded into an expansive multimedia collaboration going on both day and night. The vastness of University Avenue demanded photos of mural size. To fit that scale, smaller slide shows gave way to an outdoor projection site, creating a landmark and a gathering place at the center of *The University Avenue Project*.

To put all of this in place, we have worked with Wing to assemble a brilliant team. Their contributions are to be found in planning and developing the Project(ion) and web sites, assembling the soundtrack, creating a multidisciplinary education curriculum, coordinating community events, and fostering worldwide public outreach. This energetic group works, inspired by Wing's explosive, revealing, troubling, and compelling images.

Wing Young Huie is exploring aspects of the human soul in the language of our time. His vision is one for art, for the medium of photography, for our community, and for humanity.

Christine Podas-Larson, President
PUBLIC ART SAINT PAUL

13

THE AVENUE

UNIVERSITY AVENUE begins near the Minnesota State Capitol in St. Paul. From there, it runs west and north into Minneapolis and on into several Twin Cities suburbs. *The University Avenue Project* encompasses a six-mile stretch of this city street, from the capitol to Emerald Avenue, where St. Paul and Minneapolis meet. It passes through culturally diverse neighborhoods, including Thomas-Dale, or Frogtown, near the capitol and Midway, a distinct community "midway" between the centers of Minneapolis and St. Paul.

Named in 1874, University Avenue originally linked the University of Minnesota in Minneapolis with Hamline University in St. Paul. When construction began on a large rail yard between the two campuses, portions of the street were rerouted. In St. Paul, the new University Avenue lay about a half-mile south of the old, following what was formerly Melrose Avenue. The original sections of the street are now part of Minnehaha Avenue.

From the outset, University Avenue has been a well-traveled street, and the crossing of Snelling and University Avenues in St. Paul remains one of the busiest intersections in the city. University Avenue is also one of the most diverse areas in the state. French-Canadians, Germans, Poles, Irish, and Scandinavians came to the area in the nineteenth century. In the late twentieth century, they were followed by an influx of Hmong, Laotian, Somali, Ethiopian, and Vietnamese immigrants that continues to this day. More so than any other St. Paul street, University Avenue embodies the ethnic and cultural diversity of the modern city and the state.

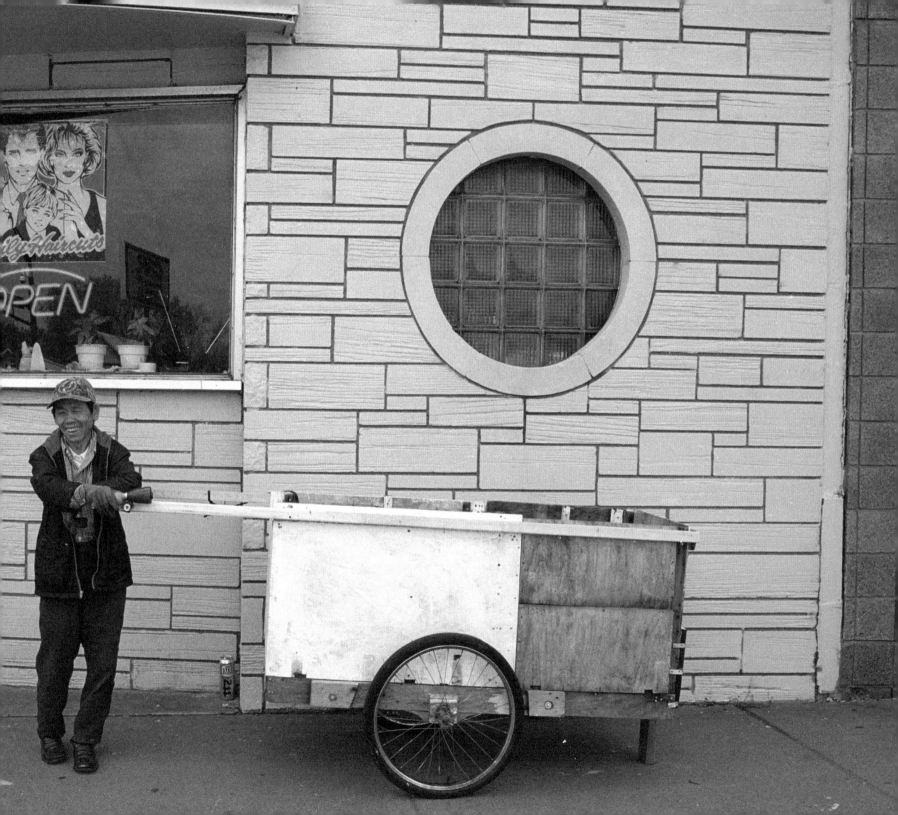

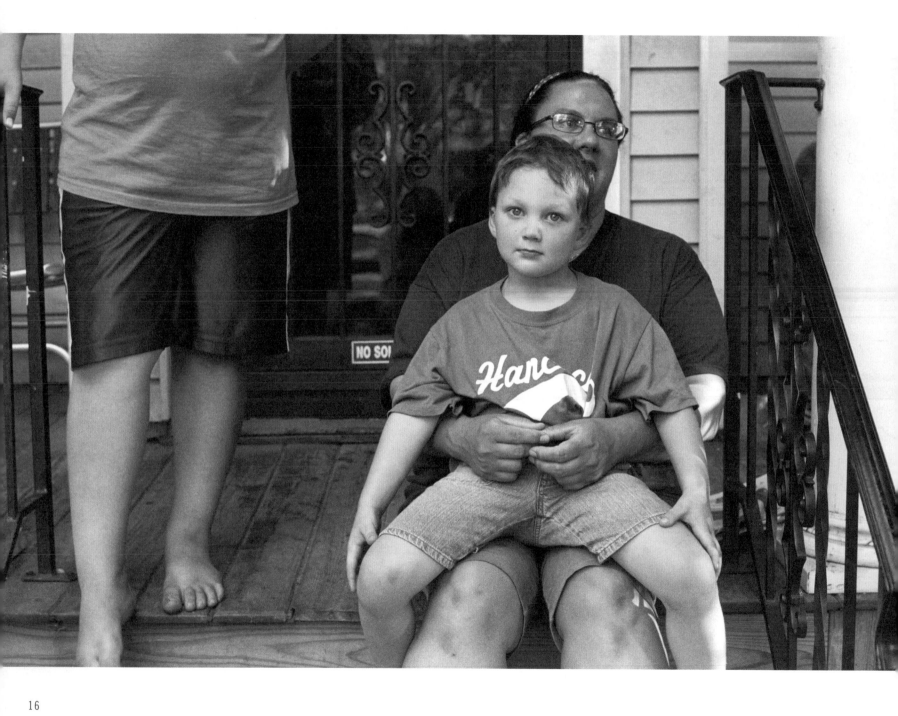

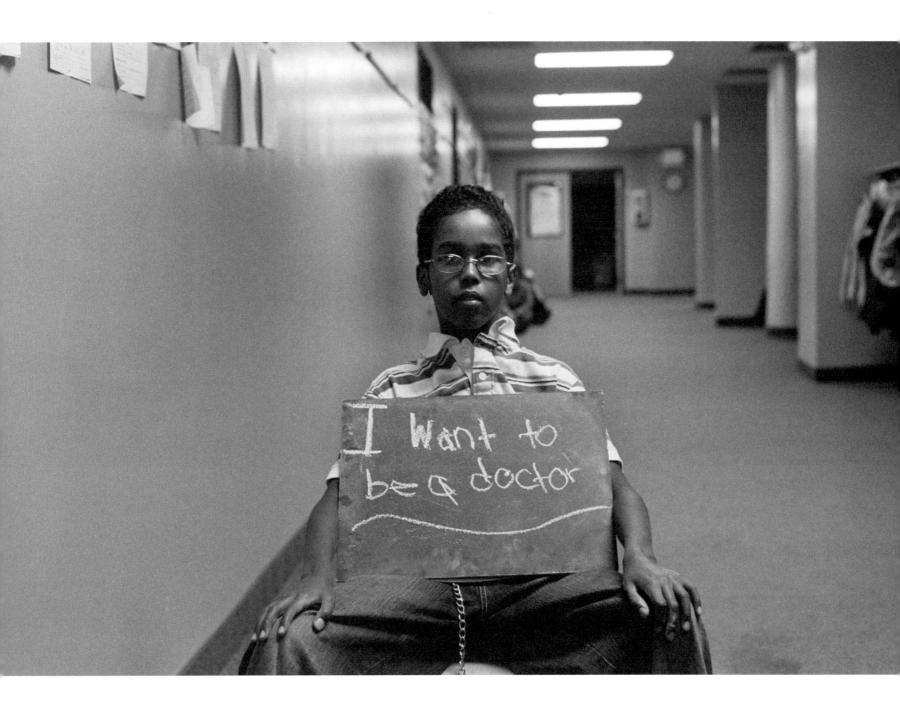

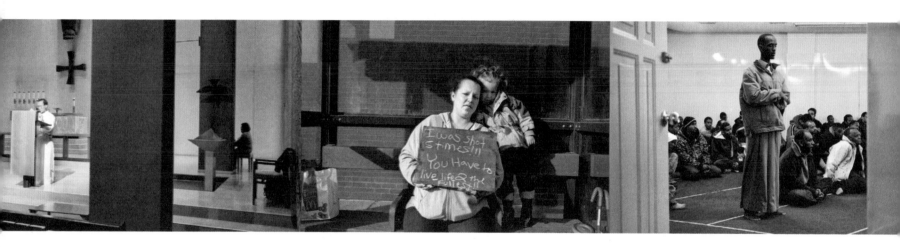

18

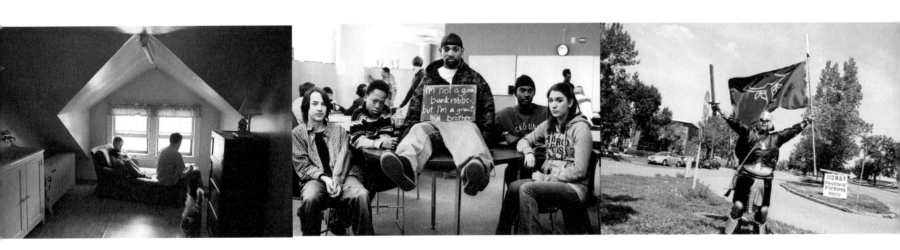

"Good morning, America, how the hell are you?"

THAT'S WHAT HE HOLLERS every morning before getting out of bed. Then it's a walk around the neighborhood. He spears trash using a piece of wood with a nail sticking out that he found while walking. Might as well put it to good use.

His mantra is "If you can do something for yourself or for someone else, do it."

It's been twelve years since he retired as a Hennepin County caretaker for mentally ill adults, but for a retired guy, he's awfully busy. His days are packed with volunteer work. His social life hums, even though he has no family and never married. "I'm still hoping," he said.

For a while he wore a button that read, "Looking for a sugar momma," but he didn't get any bites.

He's lived in the same house his entire life. He was adopted as a baby and grew up an only child. His adoptive mother also was an only child. Possibly being the last of his line doesn't bother him in the least. He thinks about the afterlife the same way. "I've been through this world once and that's enough. And I don't want to come back as anything else."

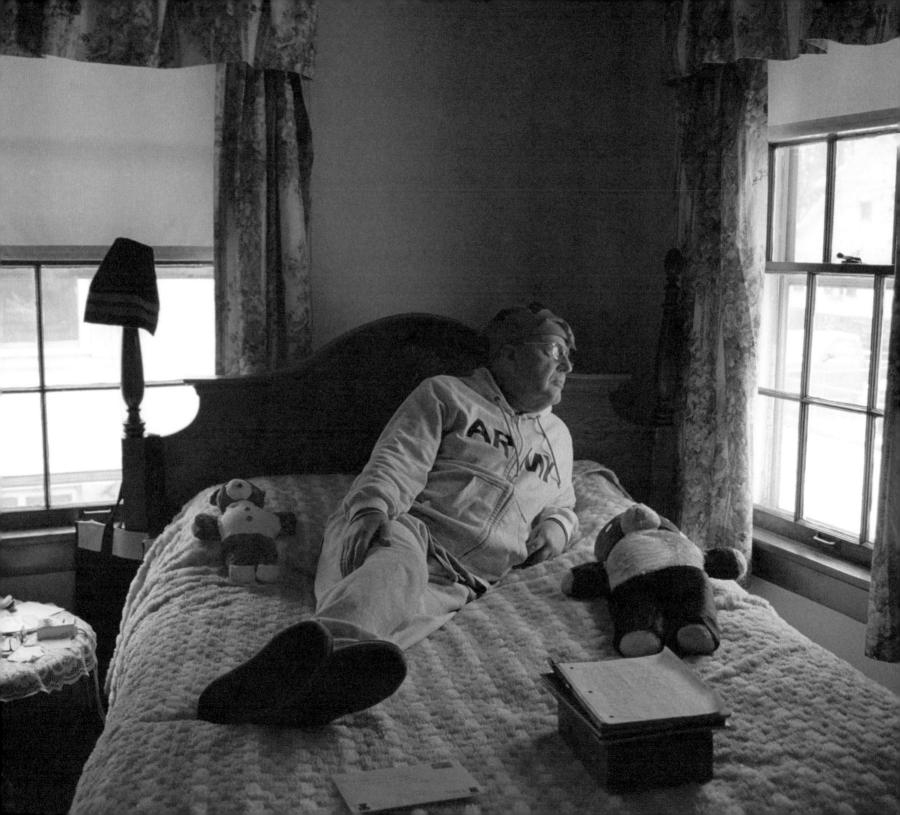

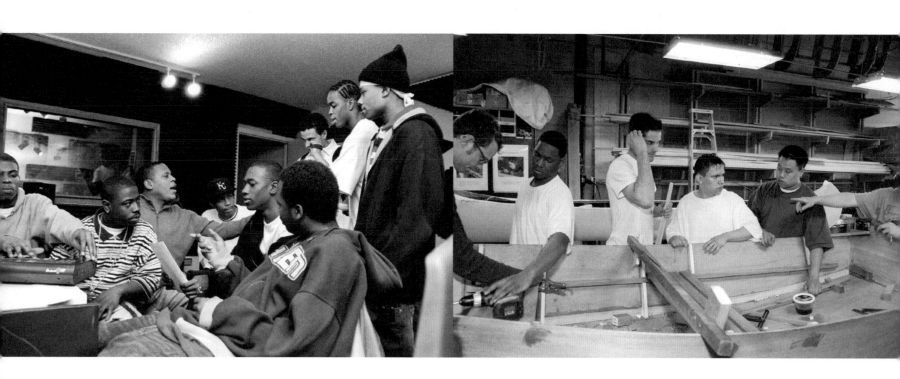

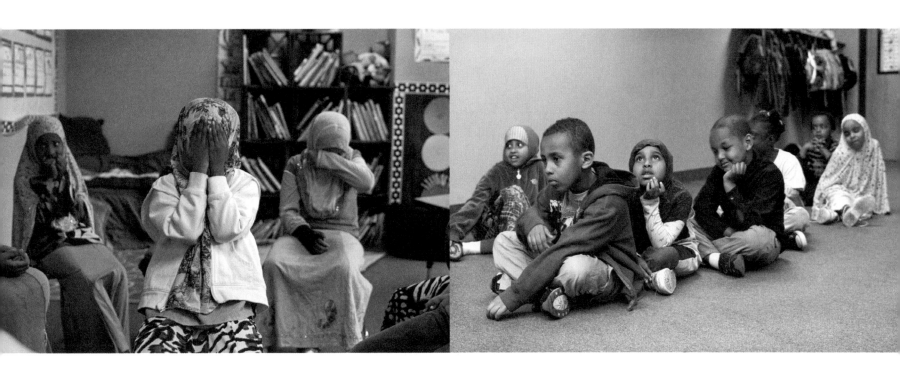

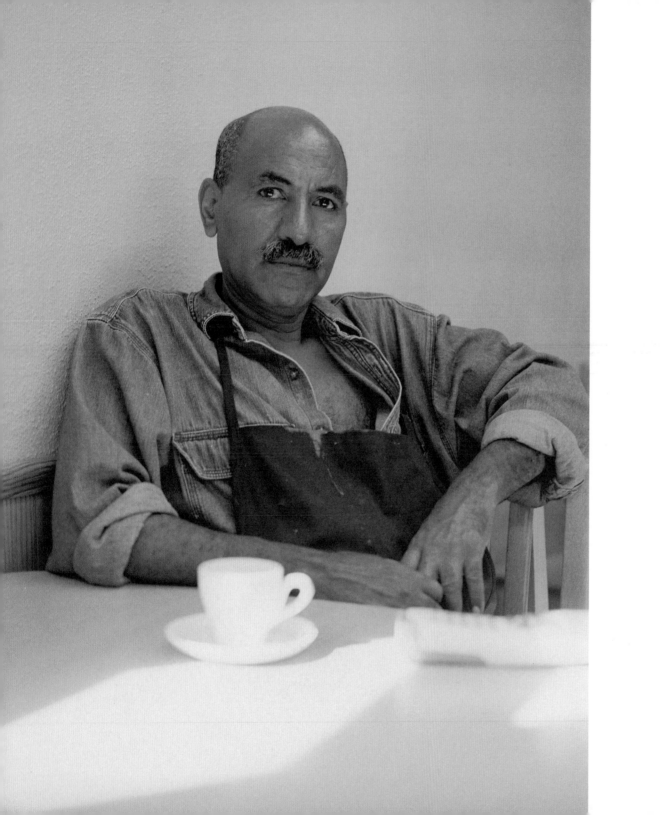

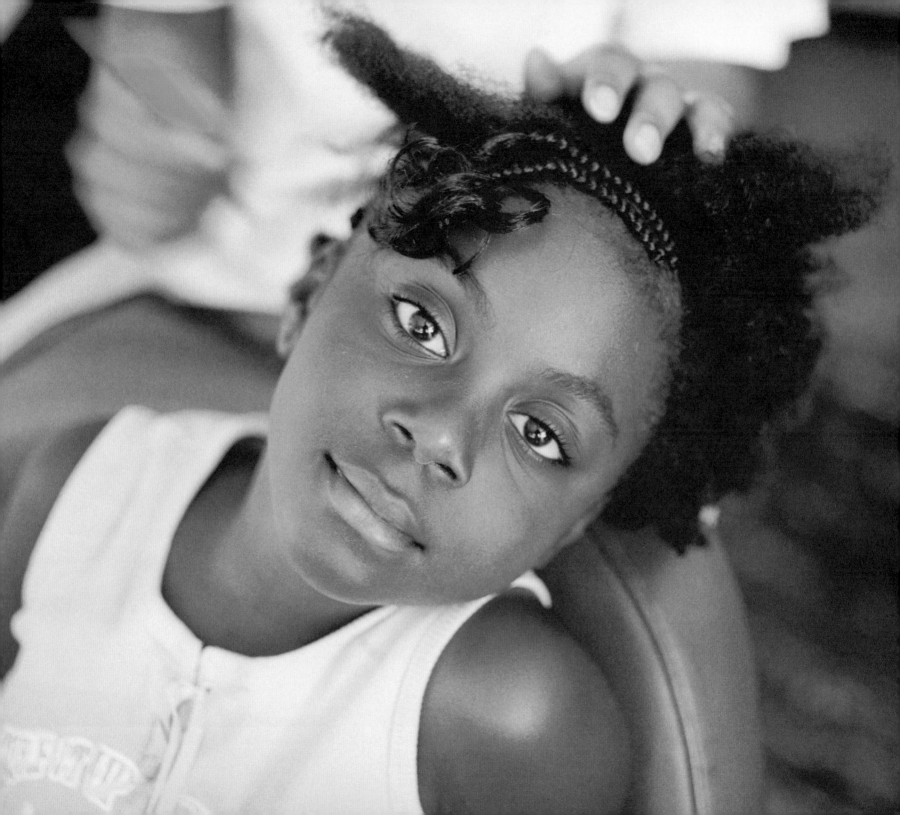

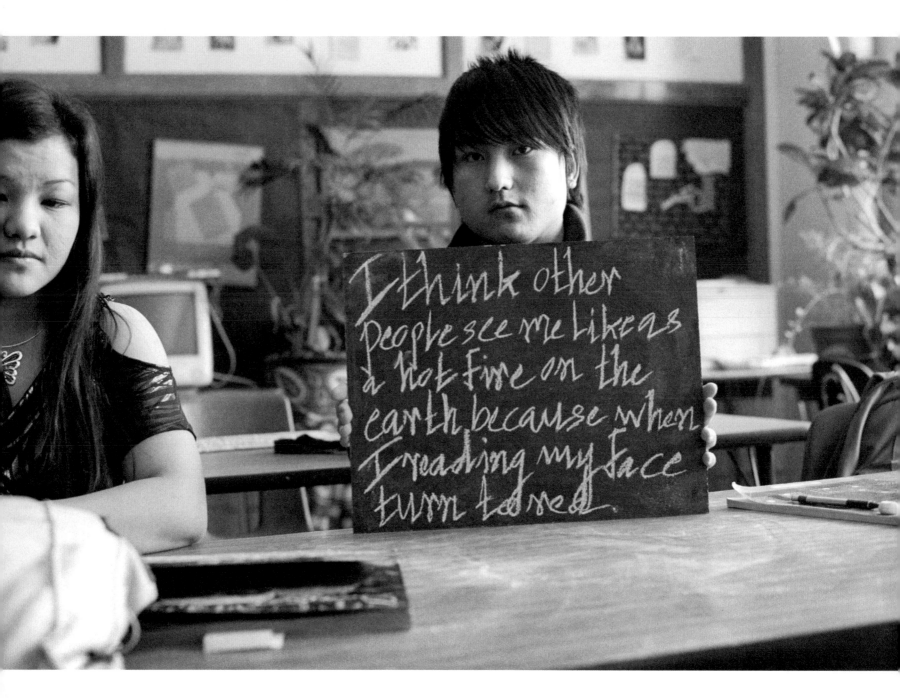

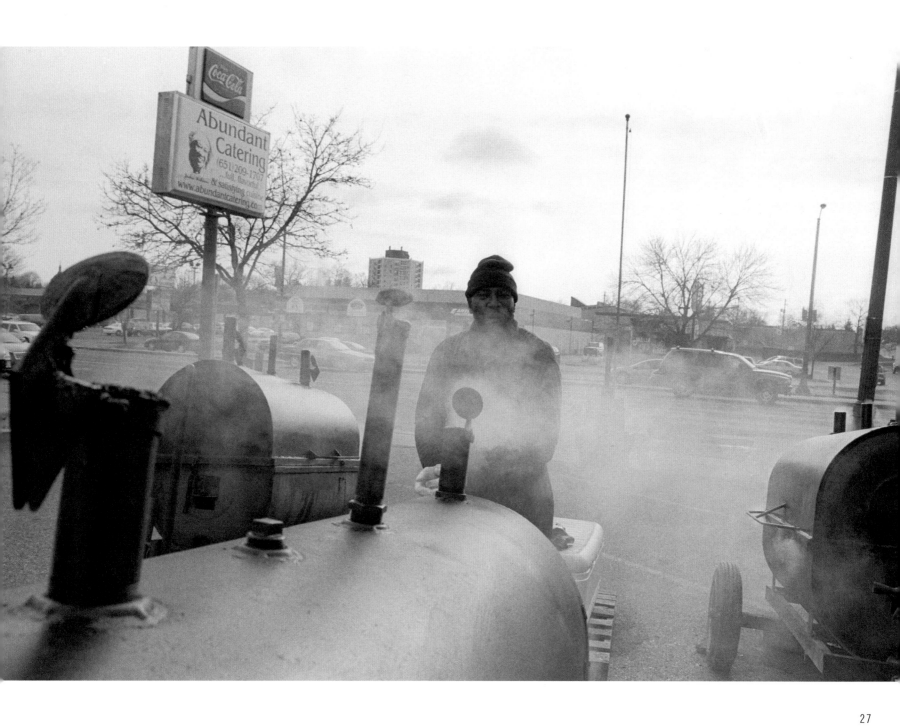

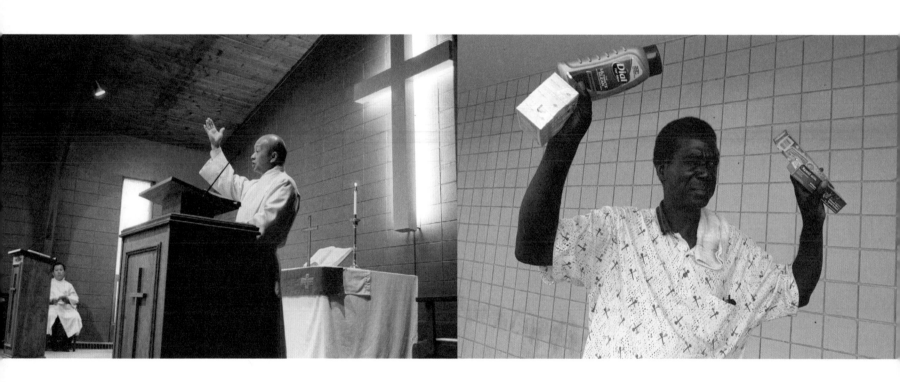

WHEN HE BECAME A CHRISTIAN, his parents told him, "You betray us. You don't respect us. You know that we worship ancestor spirits."

The pastor is only one of a large number of Hmong who have turned from their ancestral religion to Christianity. The shift has caused much conflict. His own parents told him, "If we would have known that you were going to be a pastor, we would not have raised you up."

Religion, I think, is an interesting filter through which to view our changing cultural landscape. There's a stereotype—still prevalent today—that real Minnesotans are lutefisk-eating Lutherans. Yet Minnesota has become home to thousands of immigrants and refugees, mainly from Africa and Asia. These newcomers bring with them a wide range of cultural and religious traditions and beliefs.

"My father says that Christianity or God is only for white people," said the pastor. "They only use the white guy to be Jesus [in pictures] and so they think that Jesus only belongs to white people." But the pastor's congregation tells a different story. His flock of a few hundred is nearly all Hmong.

My experience as a photographer also reveals a more nuanced image than that of the Lutefisk-eating Lutheran. In the last several years, I have photographed more than fifty churches of various denominations. Just in the Twin Cities, I've photographed over twenty Lutheran churches with congregations that are Hmong, Tanzanian, Sudanese, Liberian, Oromo, Amhara, Latino, Anuak, Khmer, Latvian, Cambodian, Lao, and Chinese.

I've never been refused permission to photograph a religious service. It's a simple exchange: their hope for my soul, and my hope for a good photo.

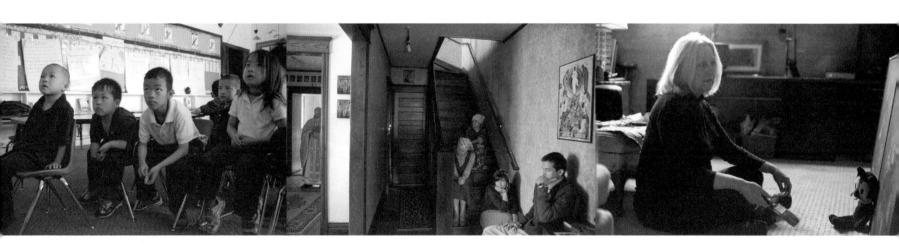

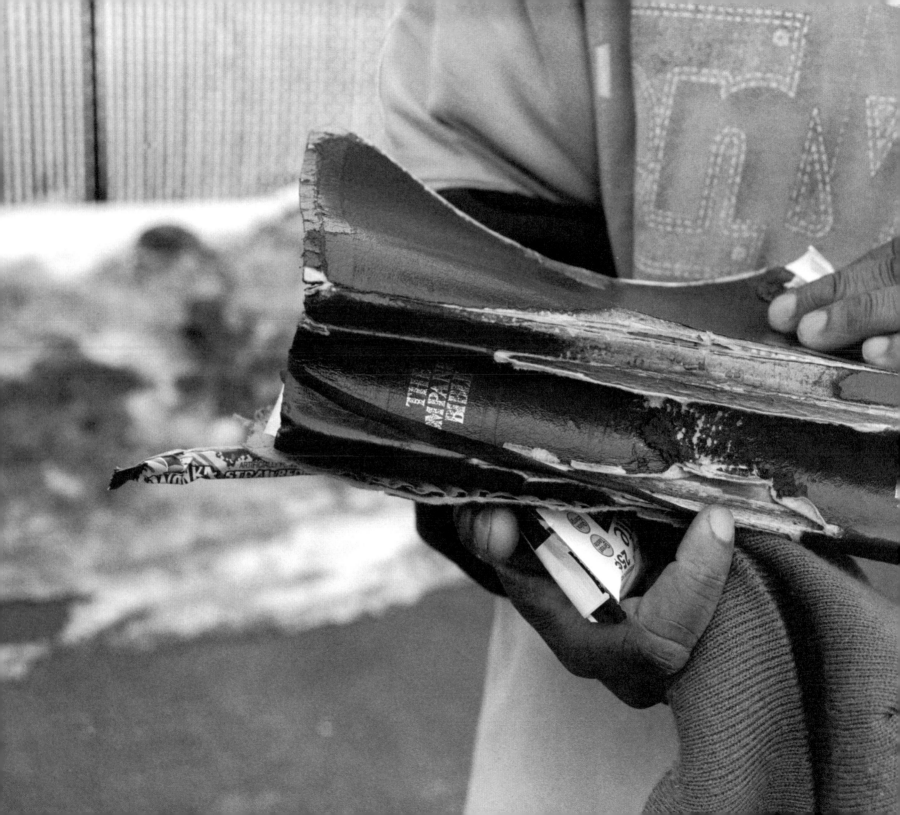

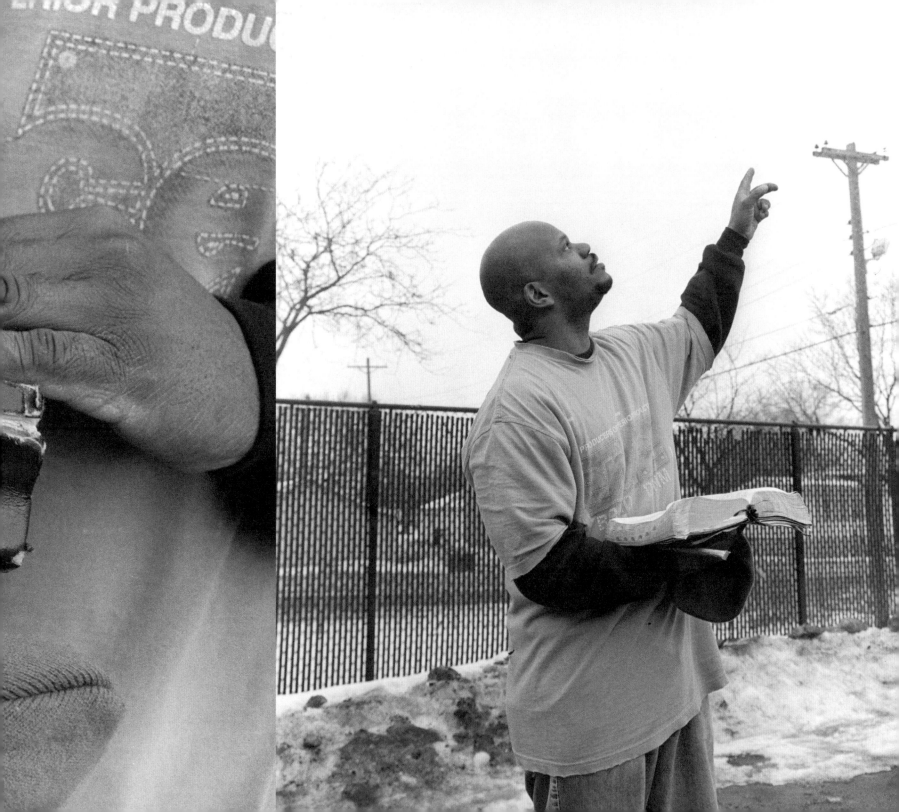

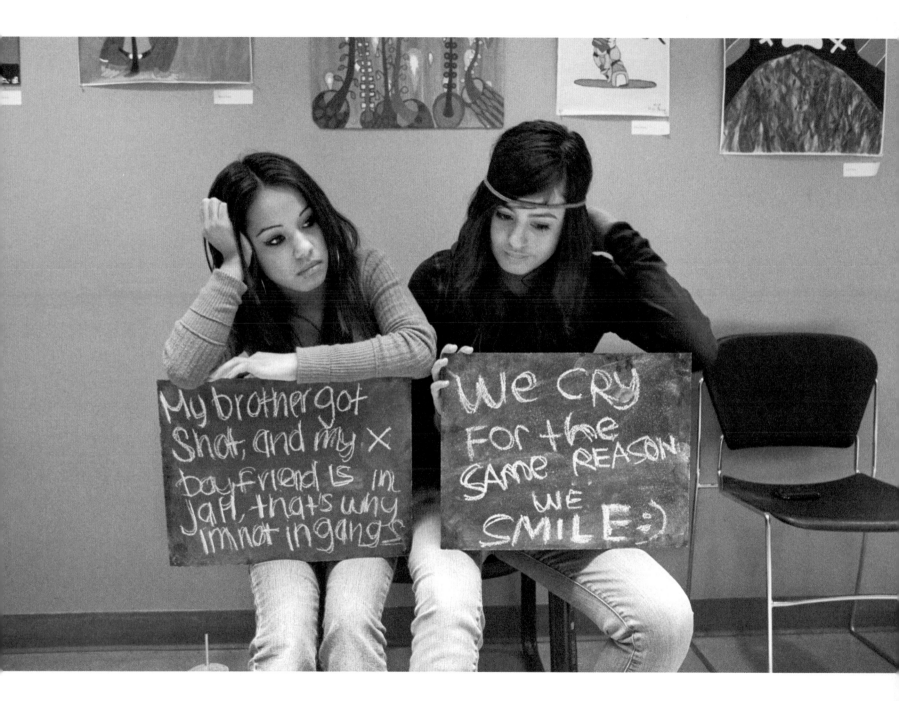

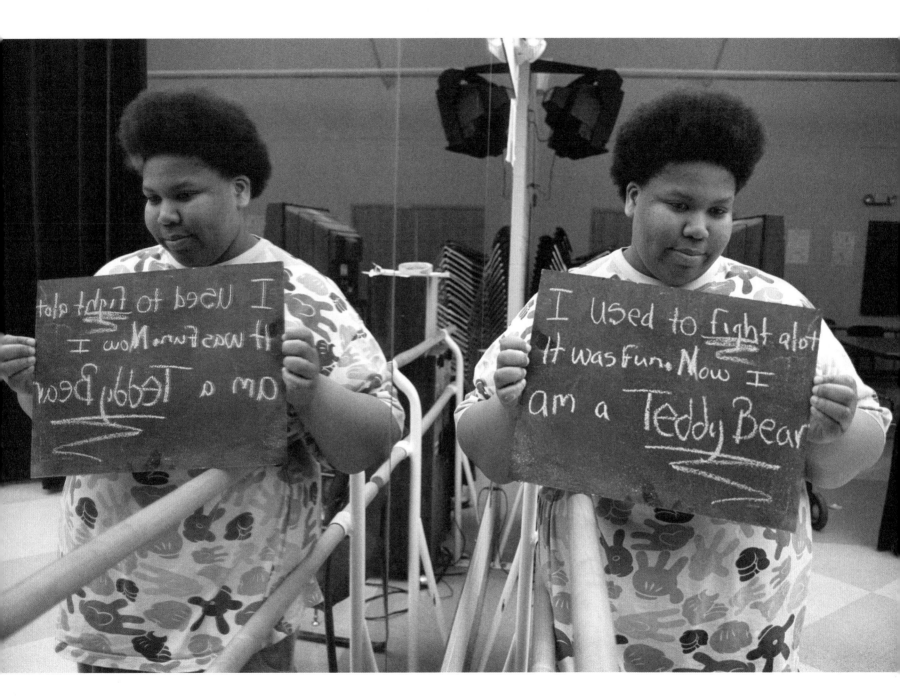

"I have a purpose every day now. It's a power greater than me."

HIS GRANDNEPHEW STOOD on the corner while he worked out of his station wagon selling Obama paraphernalia. It was still a few months before the 2008 election, and business was good.

He'd started seven months before, when he got out of treatment for the umpteenth time. He had no money, but Obama was campaigning in town and a friend fronted him two shirts that read, "Change is coming."

A couple of days after he sold the shirts he got his peddler's license and started hawking his wares on University Avenue, pulling a little red wagon. "I have a purpose every day now. It's a power greater than me," he told me then.

While selling t-shirts and bumper stickers, he registered over two hundred voters. He even donated a couple hundred dollars out of his own pocket to the Obama campaign.

Recently he spoke to a class of Hubert H. Humphrey Job Corps Center students. He told them that because of Obama, "The ceiling has been taken off. All things are possible now . . ."

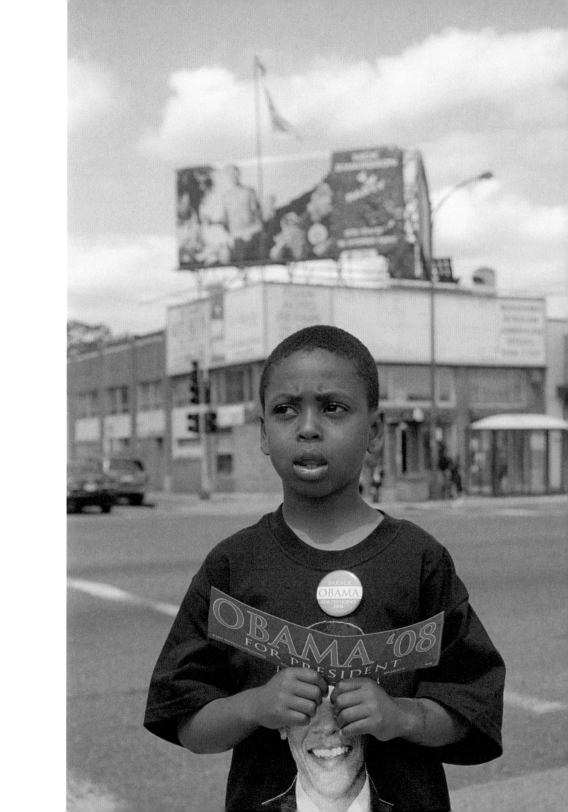

no money
no honey
no bunny

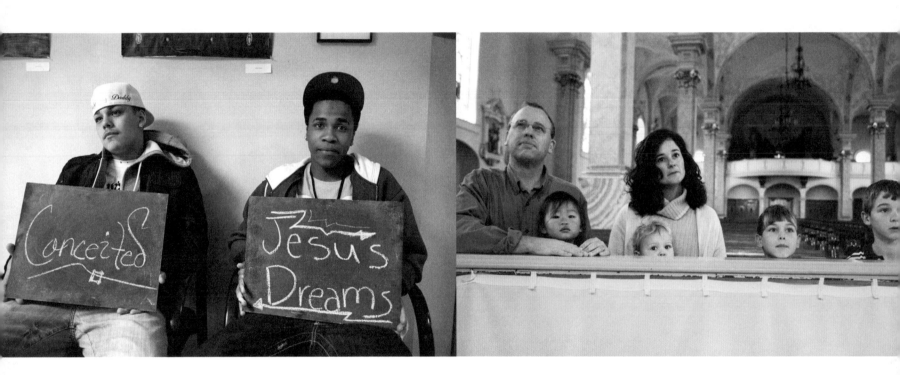

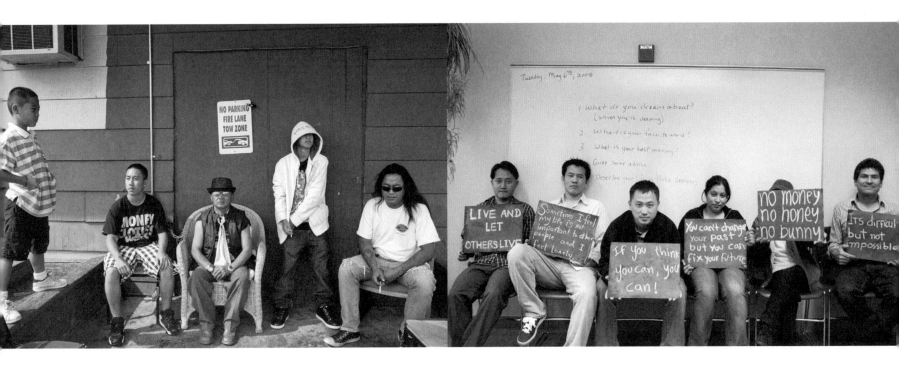

41

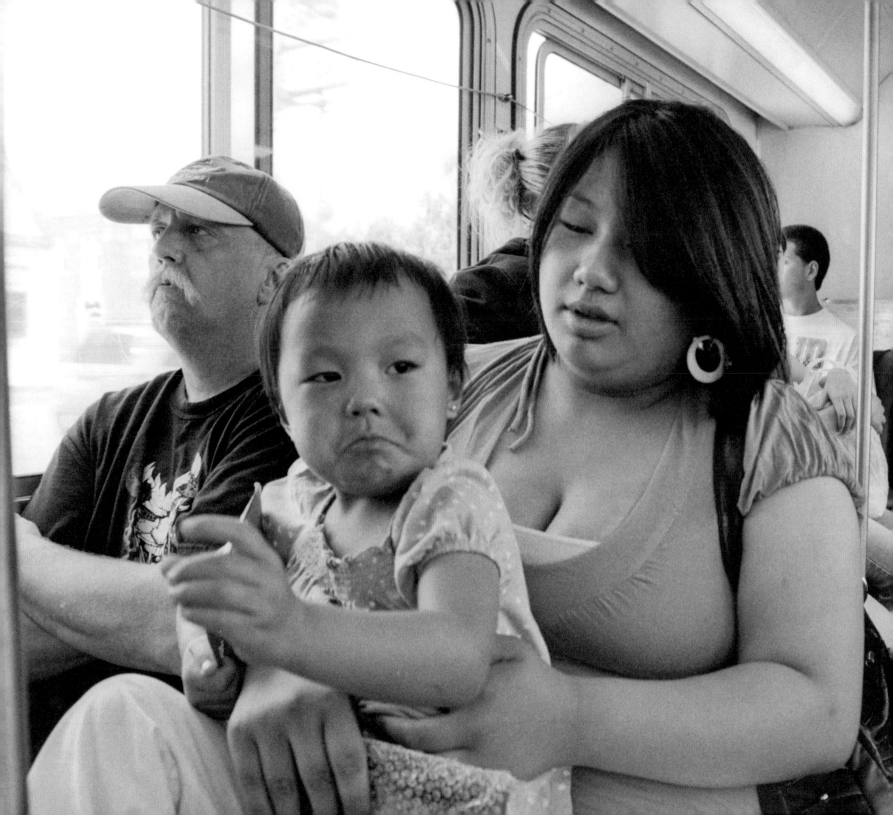

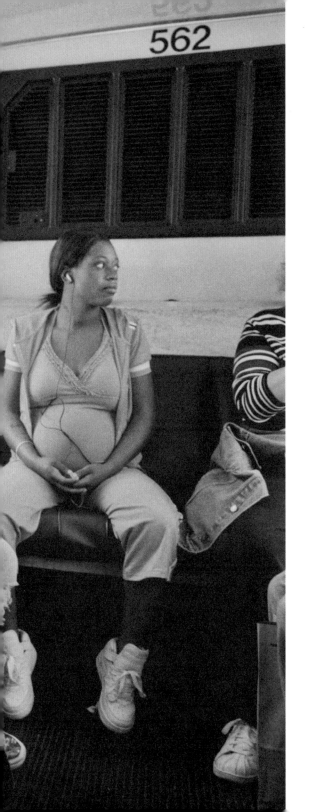

I am

I am a bird with broken wings
I am a baby-turtle racing for
 the ocean
I am a single-teen parent
I am a struggling high-school student
 I am the life of my daughter
 I am a victim of abuse
I am the eyes for my mother
 I am the care for my father
I am the oldest of seven children
I am a teacher to my siblings
I am the bonding of my friends
 I am Courage

45

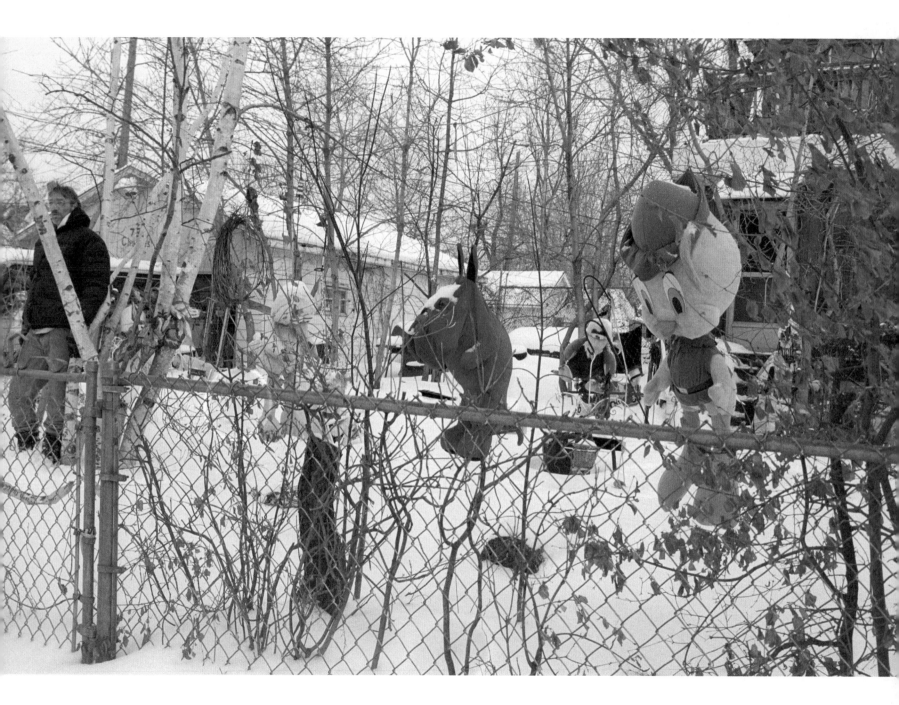

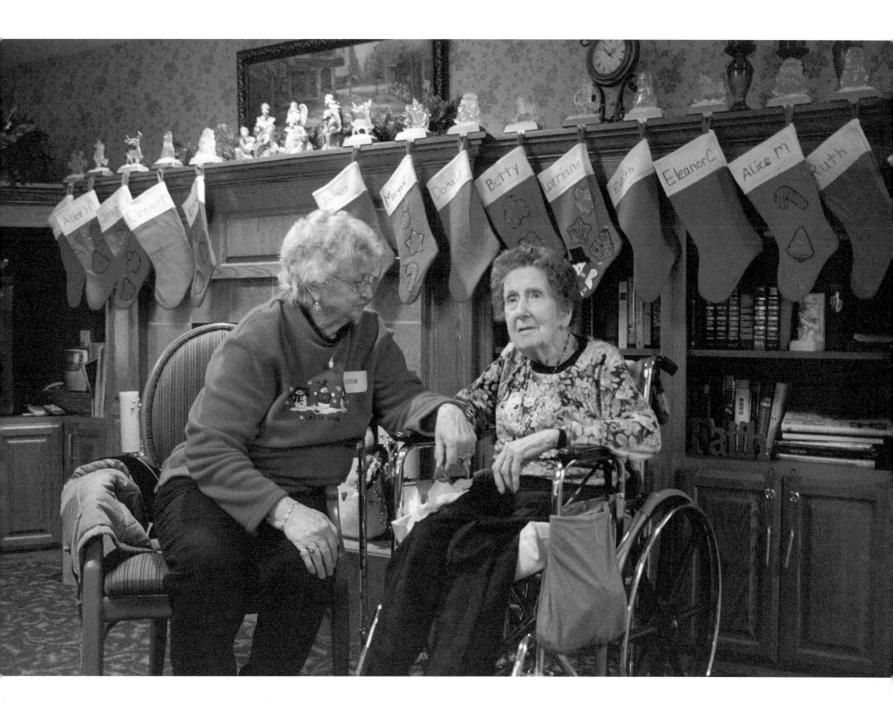

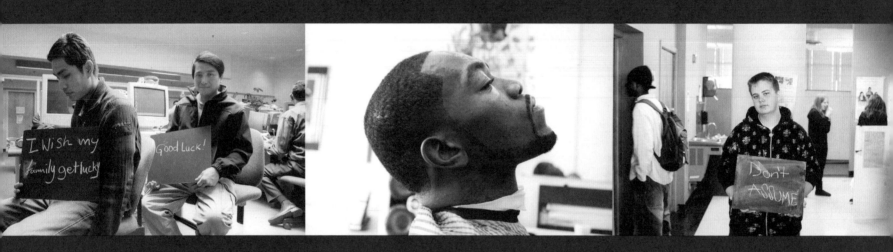

48

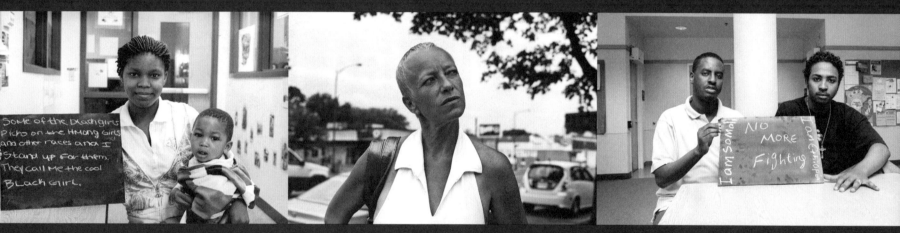

49

"Like messages in a bottle, the words bubbled up."

FOR THE MOST PART, I've photographed in a documentary style, trying to minimize my presence. It seems to me that the best photos look as though they take themselves. But with this project, I decided on a more conceptual approach.

For the chalkboard photos, I approached hundreds of people in various situations, asking them questions about identity and race, or even about their favorite word. I asked the participants to write one of their answers (chosen by me) in chalk, turning the simple boards into black-and-white mirrors of the self. Like messages in a bottle, the words bubbled up, bringing to the surface a wealth of emotions and needs, prosaic and philosophical wishes, private and public fears.

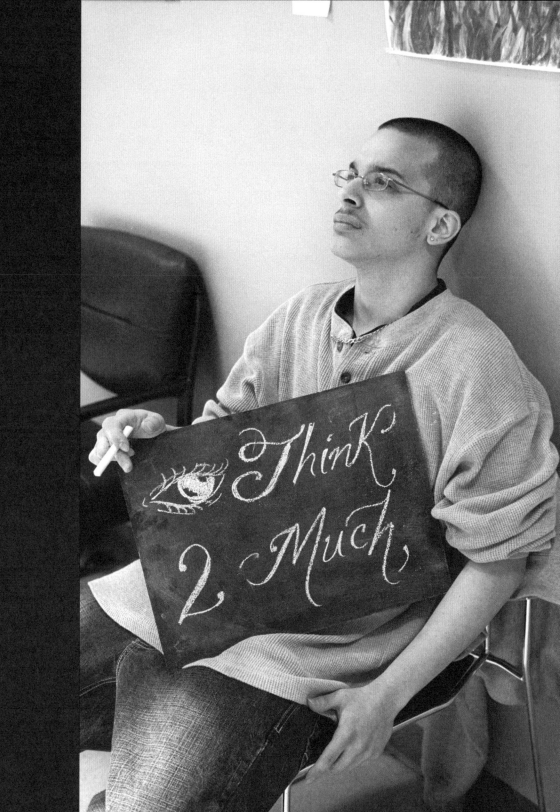

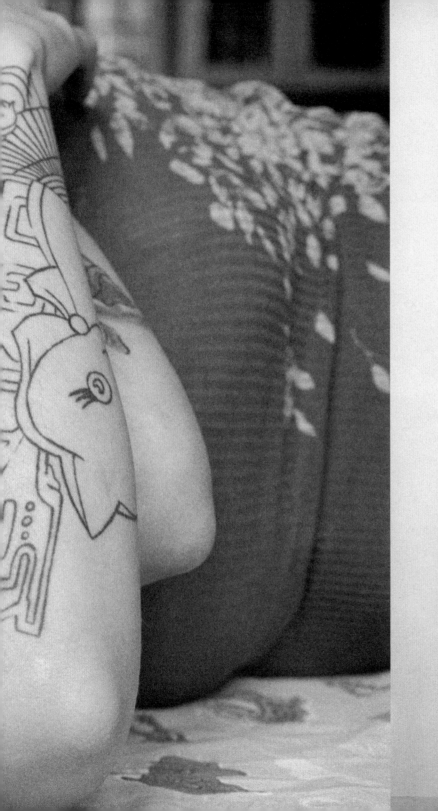

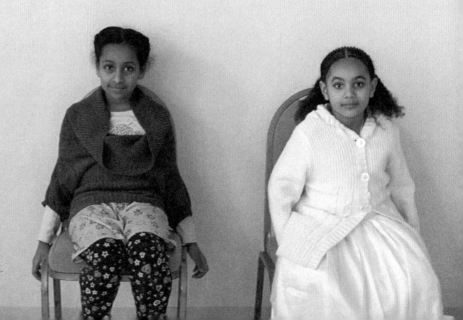

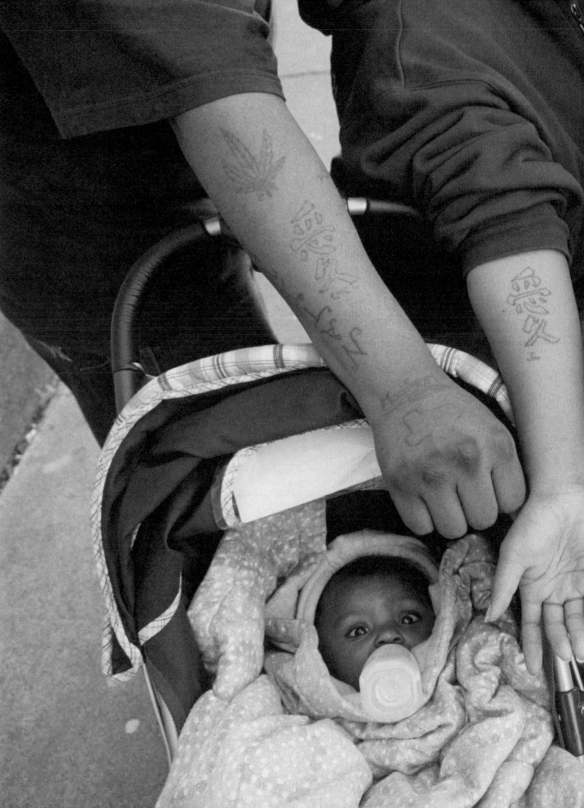

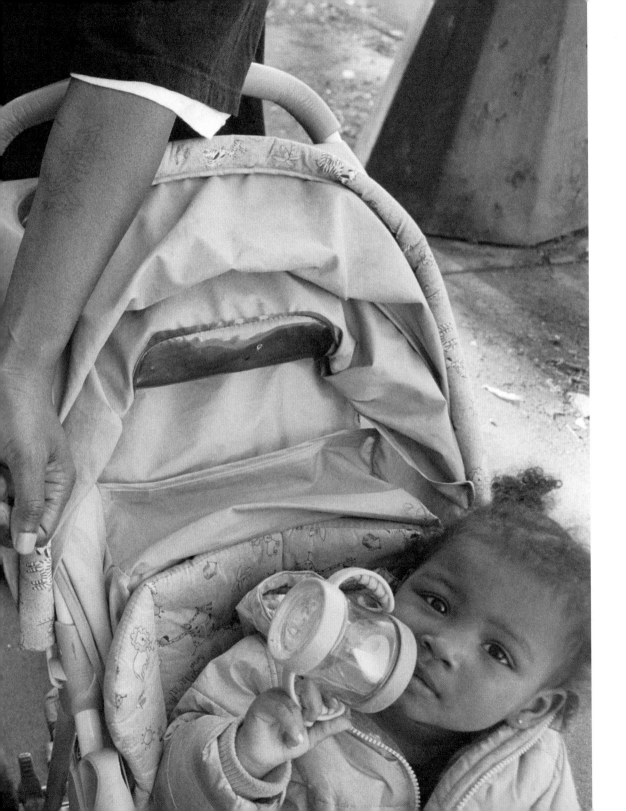

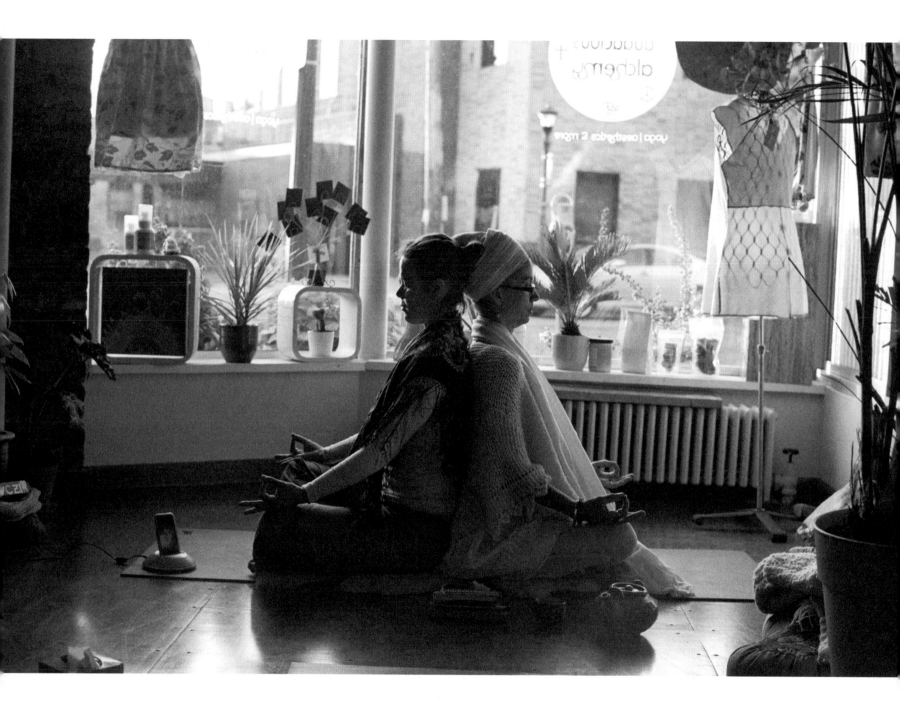

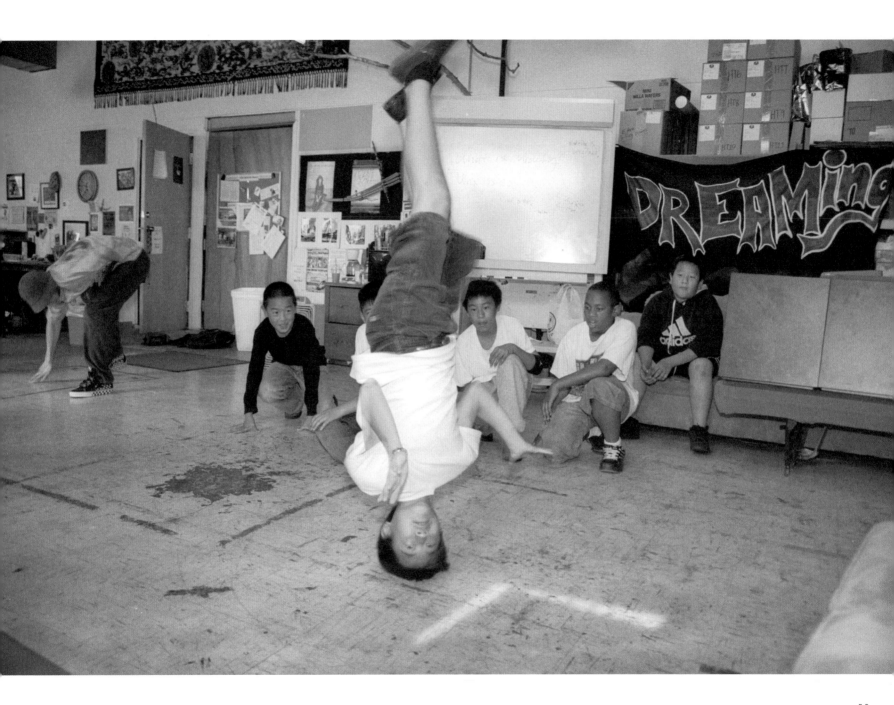

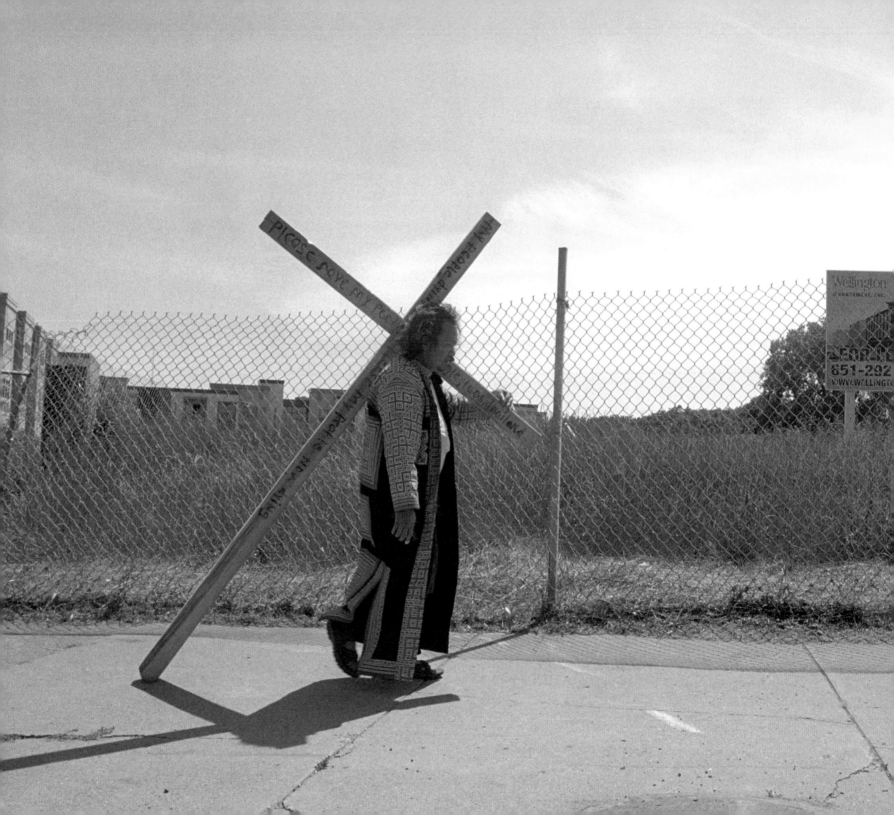

AS A BOY, before all this happened, he dreamed of flying. Then he wanted to train as a shaman. He was a teenager when he became a refugee.

He talked about how Hmong men in Laos helped the United States during the Vietnam War. How, after the Americans pulled out of Vietnam, communists came into power in Laos, and the Hmong were no longer safe.

He and his family were hunted like animals for six months in the jungles of Laos on their way to a refugee camp in Thailand. Thirty years later, Hmong are still hunted in Laos.

"Nobody knows. Nobody cares," he said. That's why he was dragging a twenty-six-pound crucifix along University Avenue.

On the cross, in his own blood, he had written, "Please save my people in the jungle in Laos and Thailand. Now."

On the morning I met him, he started out on the Minnesota State Capitol steps, having sent out a press release the day before. Nobody from the media showed to cover the story. Undaunted, he began walking to downtown Minneapolis—a distance of nearly ten miles—stopping at various politicians' offices along the way. At each stop, he read a one-page statement in the hopes that someone would do something to save the Hmong.

He never learned to fly and never became a shaman. But he did end up owning a small grocery store on St. Paul's East Side. In 2004 he gathered a dozen people, including his teenage son, to walk to Washington, D.C., to raise awareness. His wife didn't want them to go. It took them two months. When they arrived, Congress was out of session. "Bad timing," he said.

Some people think that he wants the spotlight, or that he's crazy. "I just decided to do a strange thing," he said. "I feel good about it. I have the confidence. It has impact."

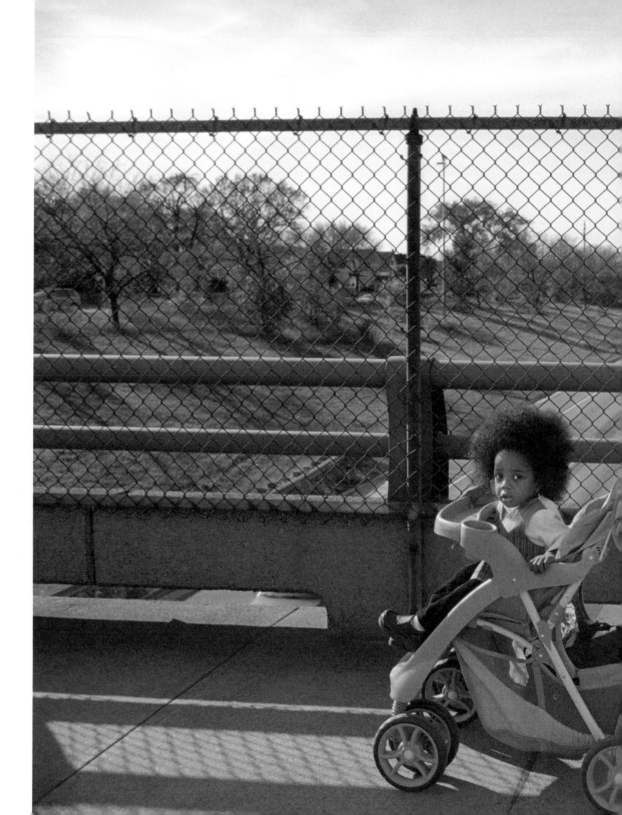

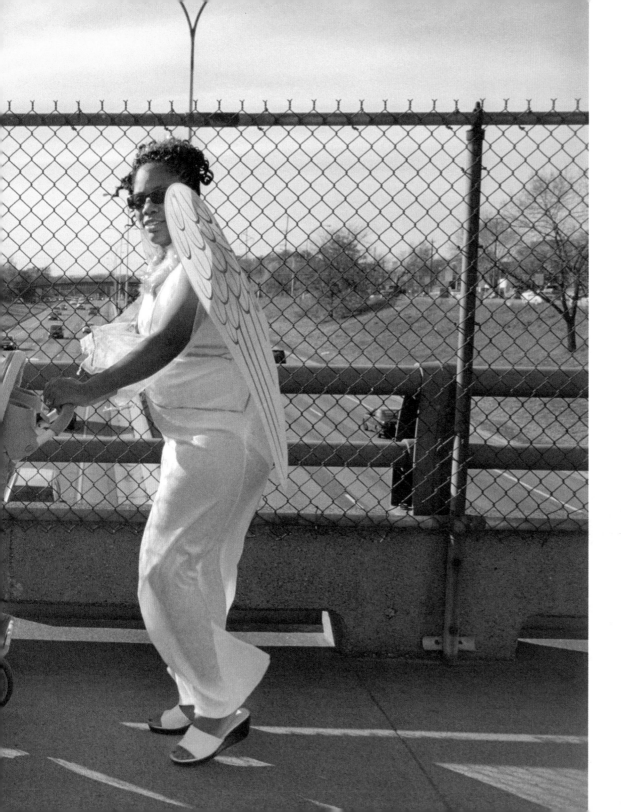

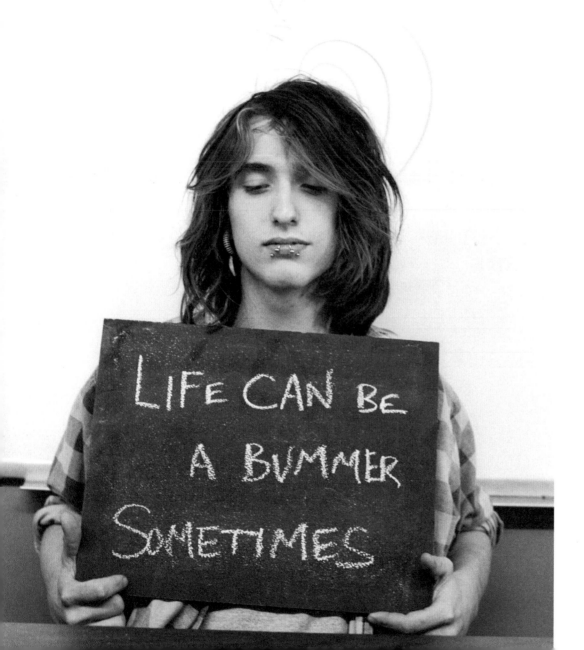

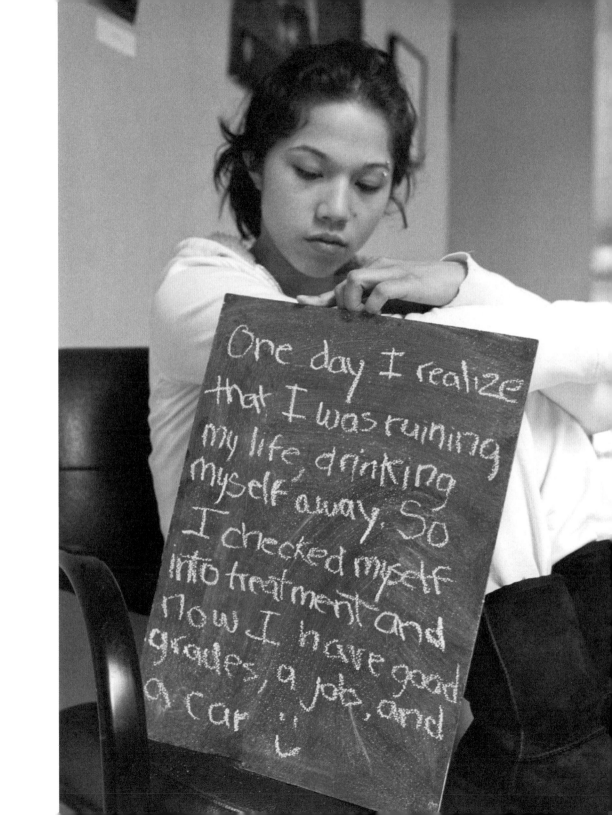

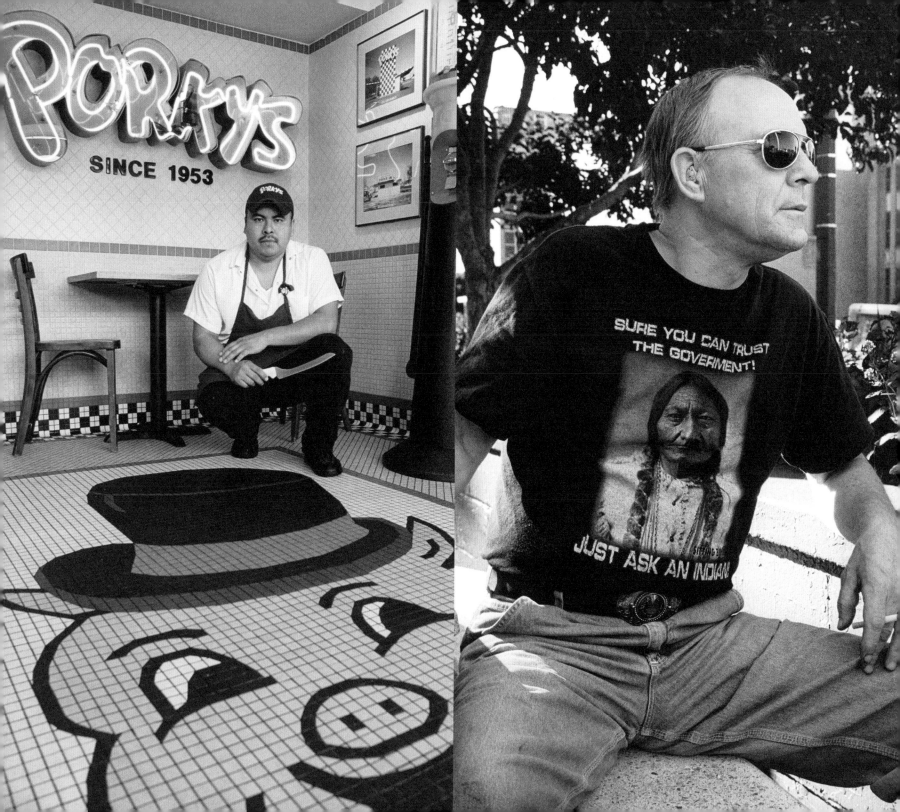

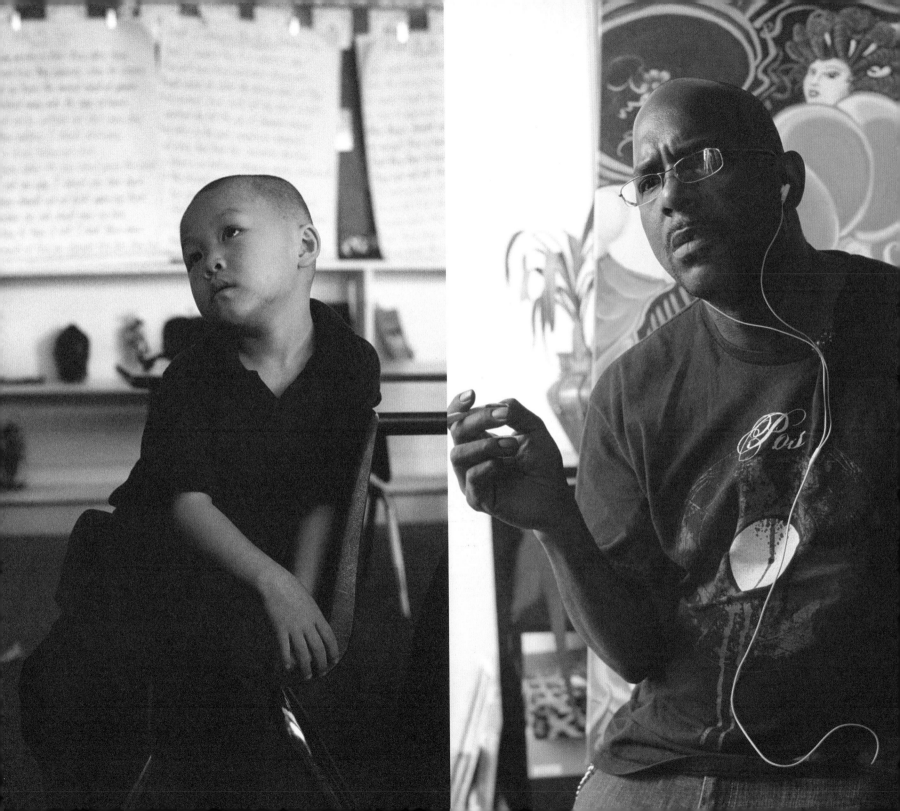

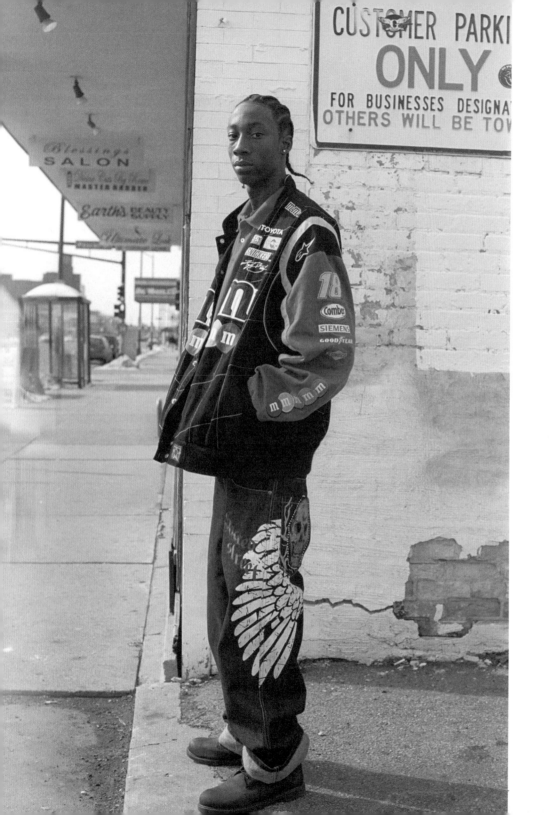

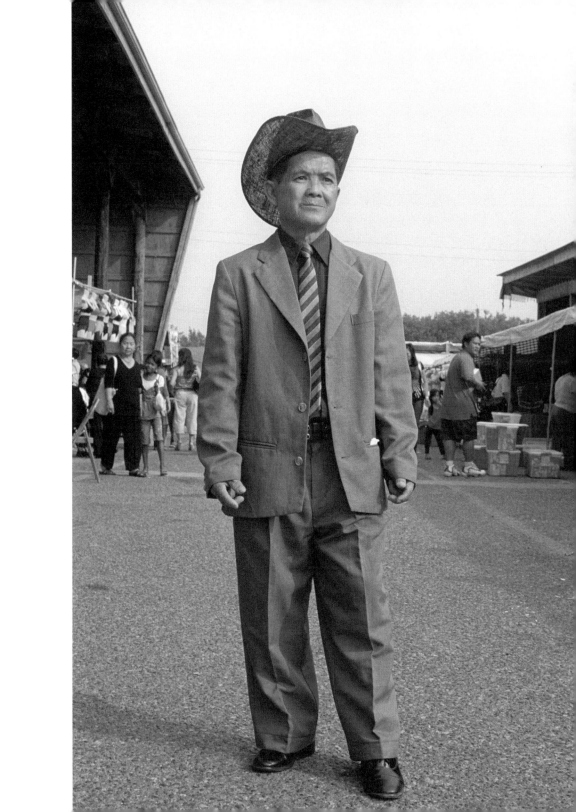

SHE WAS EIGHTEEN AND HOMELESS, living in transitional housing with her young daughter while attending high school. She was going to go to college and become a nurse. Or maybe she'd be a lawyer. "I don't like to study, but I like to talk," she said. "I'm really good at making people feel guilty. I'm good at persuasion and manipulation."

As I do sometimes when I'm figuring out how to photograph someone, I asked her what her most prized possession was. Without hesitation she pointed to the duck. Then she explained.

Her father died when she was twelve or thirteen. Sure, he had some problems. He was an opium addict. But she still thought he was a good father.

They would go to the food shelves together and fill up a whole garbage bag. She laughed at the memory. Then there were the times when he took the family out fishing, or when he would call her his "special one."

He was tough, too. One time some men came over to the house and demanded money. Her dad pulled out a gun and made them all get on their knees. "I don't owe you nothing," he told them. That really impressed her. "My dad was so gangsta!"

Just a few months before I met her, she was in a thrift store and saw the duck. Something about it was familiar. She picked it up, unscrewed the head, and then it hit her: *Omigod,* she thought. *It smells like my dad. He had a cologne bottle just like it. This could be his.*

There was no price tag. She thought of offering five dollars, but decided to come back the next day. It was still there and marked only seventy-five cents. That was a very happy day.

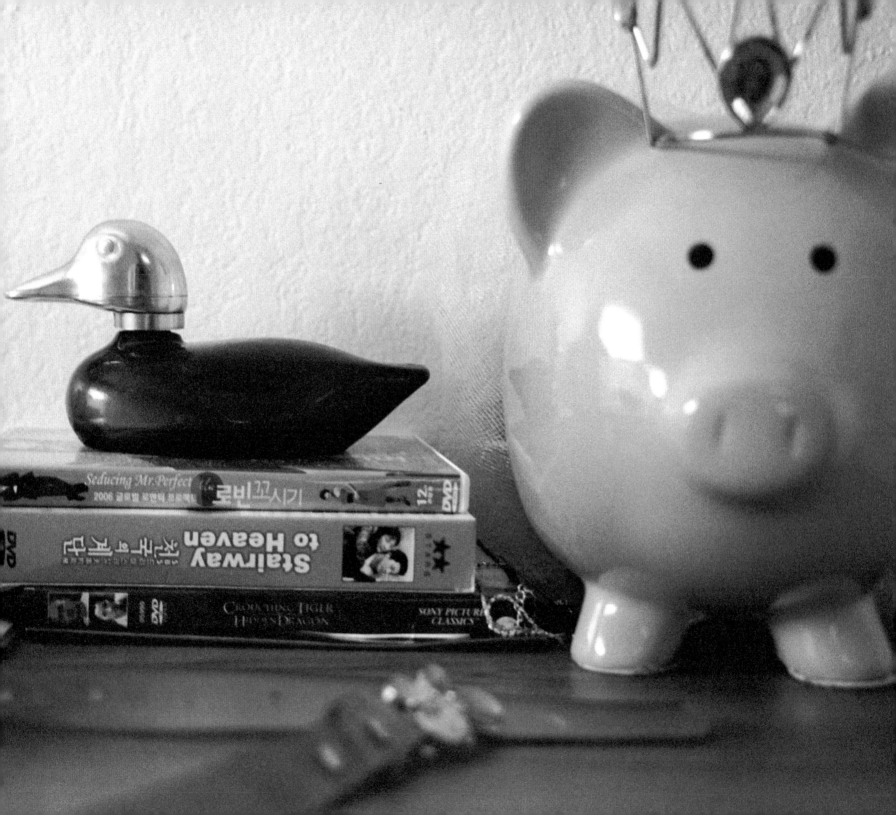

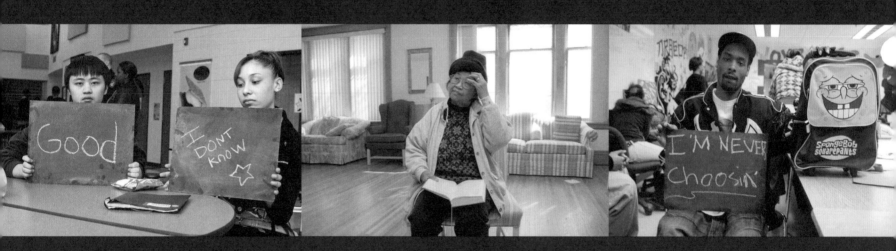

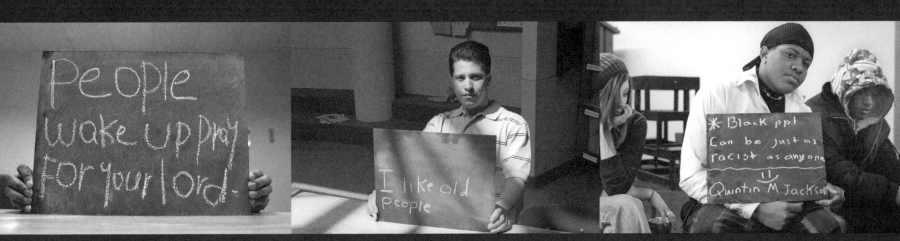

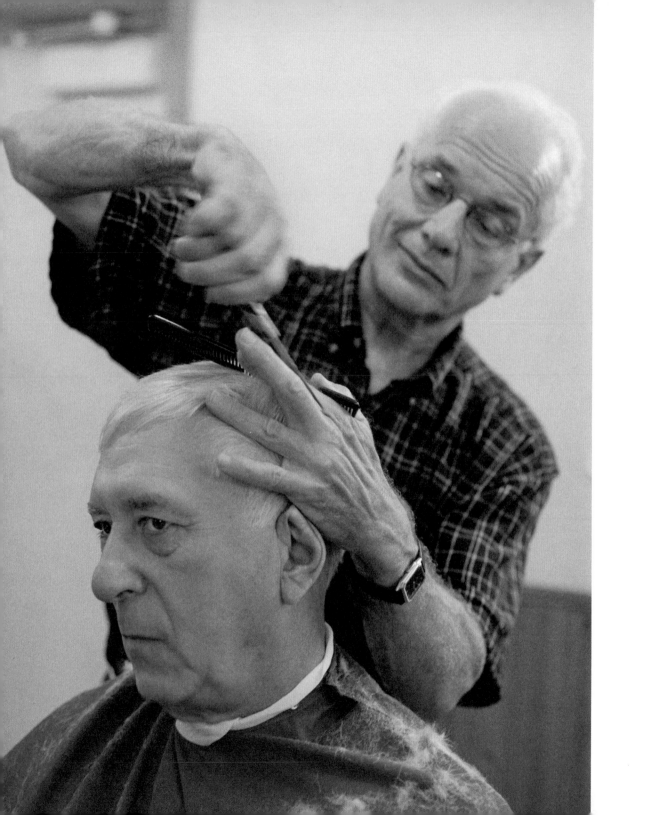

"He wonders sometimes why she did what she did."

SHE GAVE HIM UP when he was a baby. She lives somewhere in St. Paul, he thinks. Works at a mall.

Maybe it was because she was young, or on drugs. He's got a photo of her somewhere, but she could walk right by him and he wouldn't know her.

He's never had the chance to meet her, never really tried. It's not at the top of his list. Someday he might look her up. For now, he's trying to better himself. He just got his GED at the Hubbs Center and wants to go to college. He thinks of himself as a positive person.

He knows his birth mother was adopted, like him, but from Korea. His birth father is black, but there's no name or face he can attach to the word *father*. He was born here but raised in a mostly black neighborhood in Greenville, Mississippi. Recently he moved back to St. Paul.

His adoptive parents are white (mom) and black (dad). But growing up, he rarely saw people from different racial groups hanging out together. The majority of white people are racist, he says, and after a while you just don't think about it anymore. In St. Paul, though, it seems to him that people get along better.

He's never really had any Asian friends before, but he recently met a Hmong guy who lives on the East Side. He has taken tae kwon do, a Korean martial arts form, and has several tattoos in Chinese characters that mean strength and dragon power. But he's never eaten Korean food: he has no idea what kimchi is.

He has ten letters from his Korean birth mother that he's gotten over the years through a social service agency. They mostly arrive on his birthday or holidays. He feels nothing when he gets them, he says.

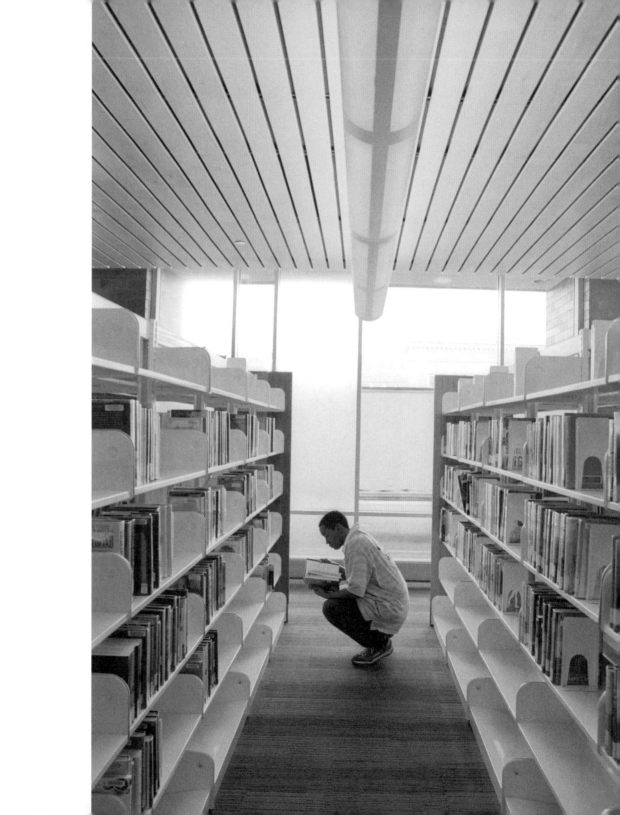

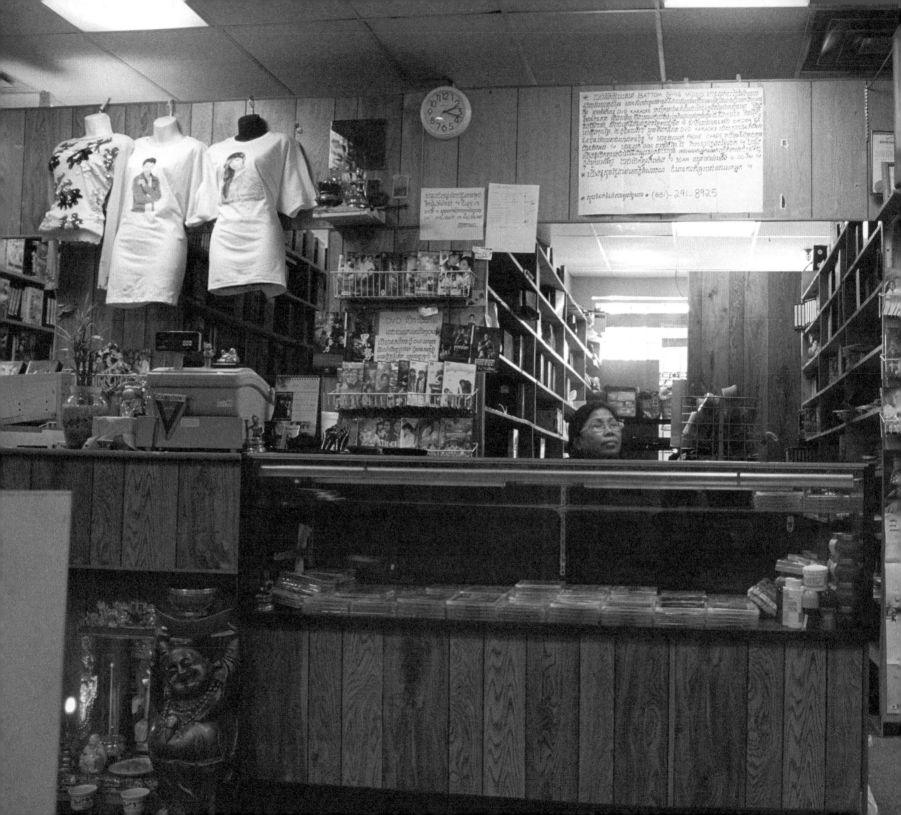

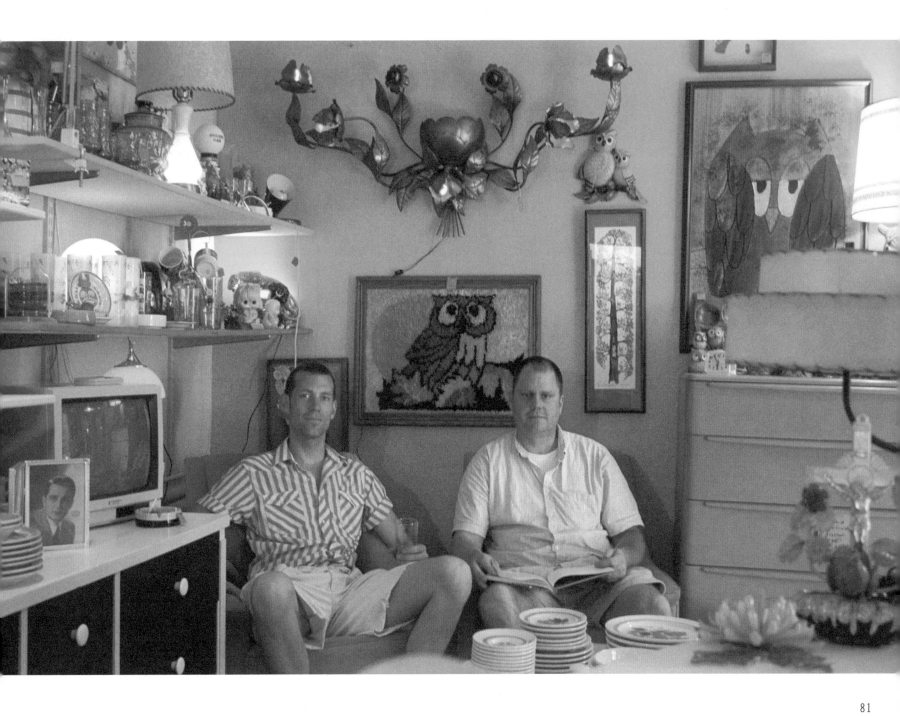

I'm a metaphorical person.
It sounds really funny, but
and unacceptable. I someti
This is what am I

like the word of metaphor

ometime it is really sorrowful

e sound a silly creature.

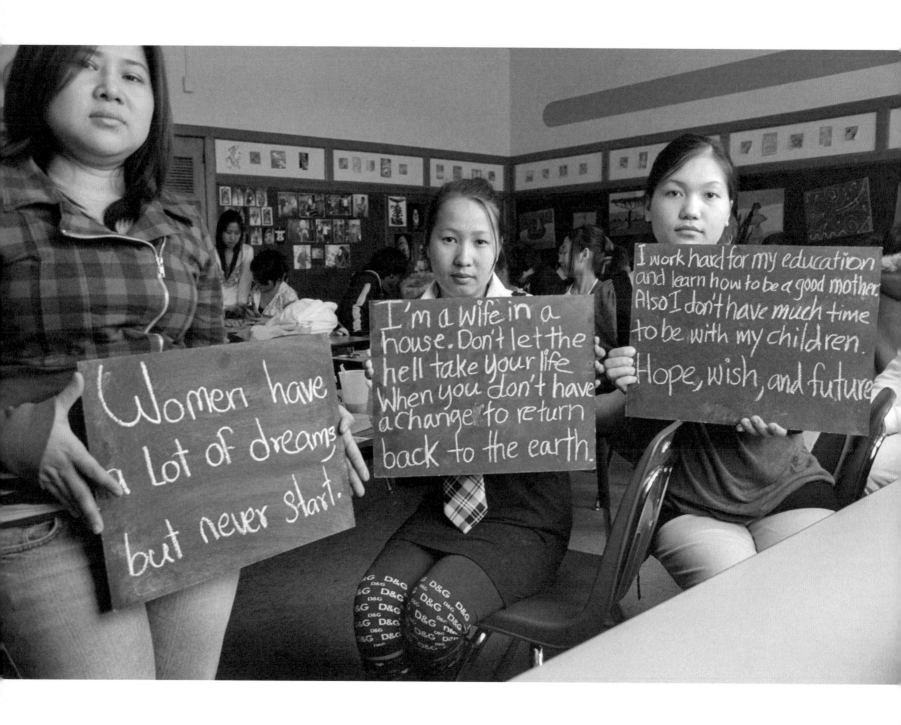

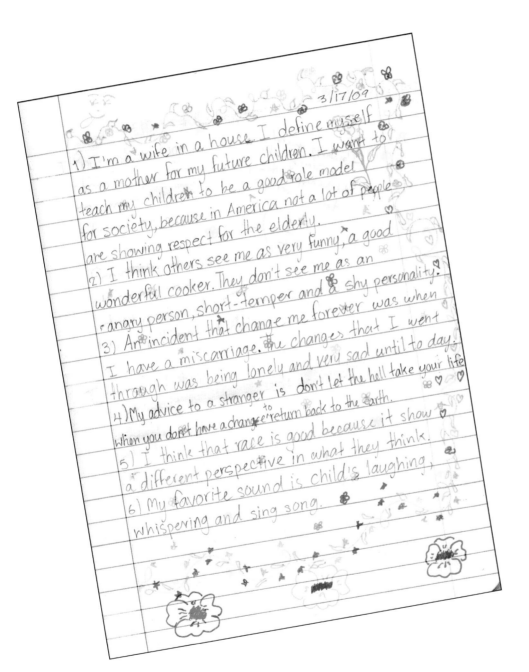

3/17/09

1) I'm a wife in a house. I define myself as a mother for my future children. I want to teach my children to be a good role model for society, because in America not a lot of people are showing respect for the elderly.

2) I think others see me as very funny, a good wonderful cooker. They don't see me as an angry person, short-temper and a shy personality.

3) An incident that change me forever was when I have a miscarriage. The changes that I went through was being lonely and very sad until to day.

4) My advice to a stranger is don't let the hell take your life when you don't have a change to return back to the earth.

5) I think that race is good because it show a different perspective in what they think.

6) My favorite sound is child's laughing, whispering and sing song.

I'M NEVER SURE HOW people will react when I ask them to be photographed—and to share something of themselves. A question as simple as "Who are you?" can lead to an extraordinary answer. Often the words on the chalkboard are just a fraction of the person's responses to my questions.

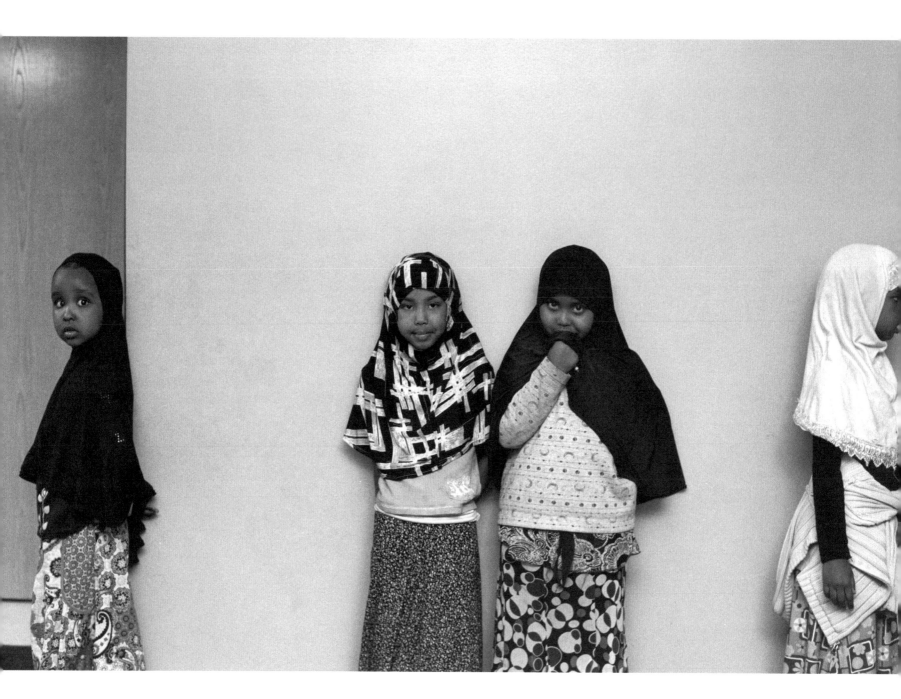

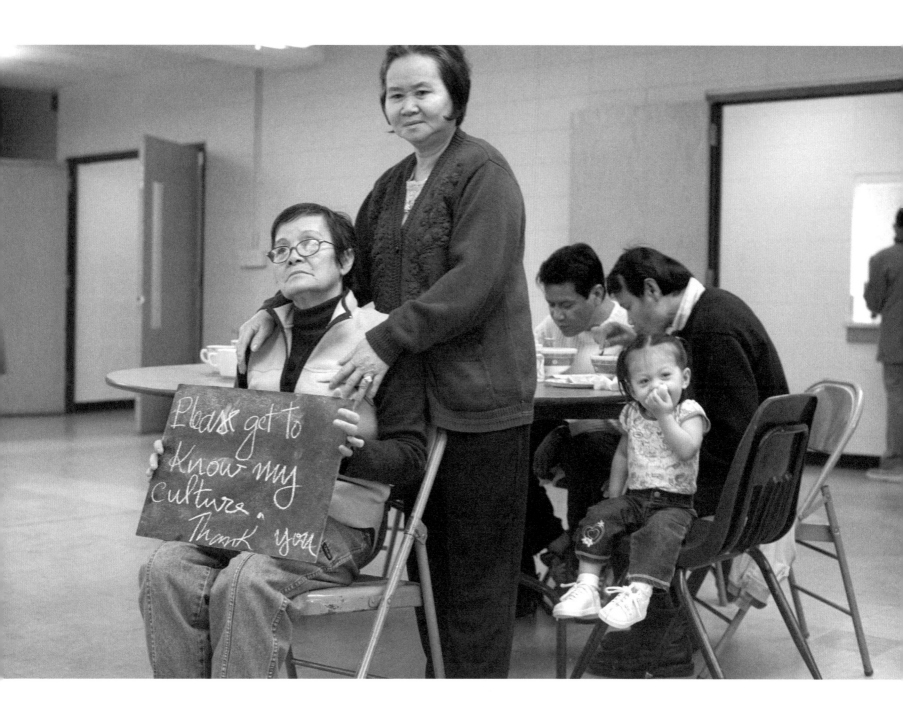

"I am the whole America."

"I DON'T BELIEVE IN nationalities. I live everywhere. Race does not affect me. I am the whole America." I asked where he was born, but he just smiled. He enjoys that people don't know what he is. He's a mirror of otherness depending on who's asking. People who meet him think he could be African American, Mexican, Filipino, Indian, Caribbean, or (after 9/11) Middle Eastern. "I'm Mr. Unusual for everybody."

He's never offended by the questions. He recently was grocery shopping when an elderly woman approached him. "Who are you?" she asked. "You look familiar."

"I'm an artist . . . ," he replied. "But some people think I'm Harry Belafonte."

Twenty-five years ago, he immigrated to Minnesota, from somewhere. Then, he told me, he "fell into the cracks." No one would sponsor him. Back home, he had been a general manager at an American embassy, but after arriving here he was turned down for a cleaning job. Undaunted, he eventually started driving a taxi, became a machinist, worked in the technology and electronics field, and then spent eleven years as a long-haul truck driver.

Lots of changes for one man. But through it all, and ever since he was a kid, he's had painting and art. He carved a bird out of a lamb horn when he was eleven. Soon, he was making charcoal portraits. Then in high school he discovered oil painting, which he's done ever since.

He's never had a teacher, but will rhapsodize in detail about Vermeer, da Vinci, Rembrandt, Michelangelo, Rafael, Picasso, and Bernini. His house is filled with canvases. They're like him: "the whole America," and more.

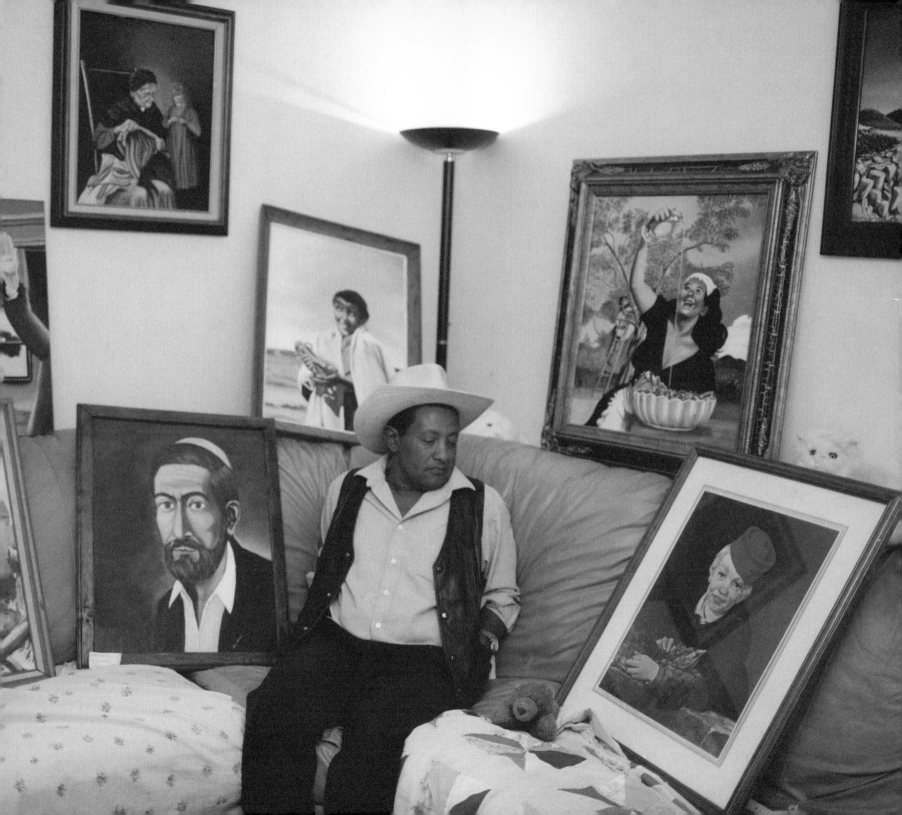

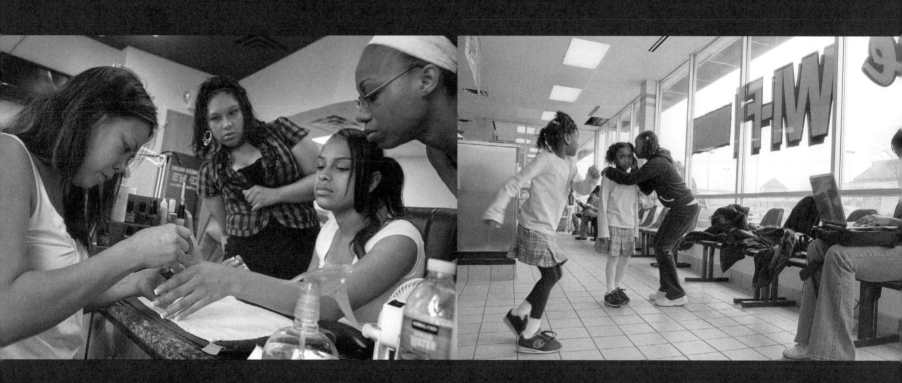

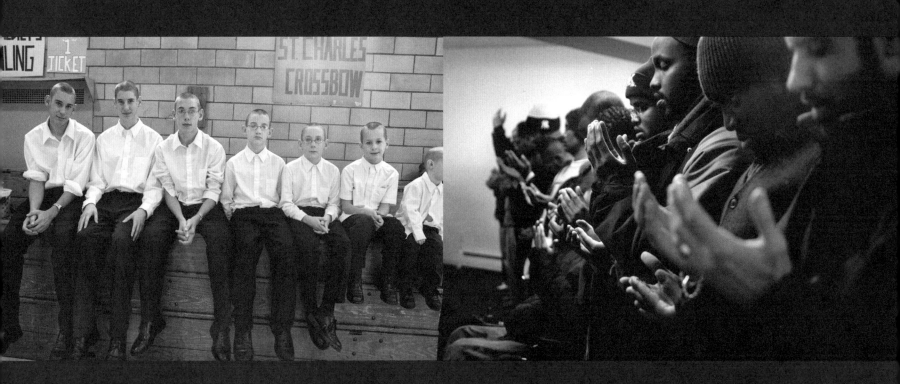

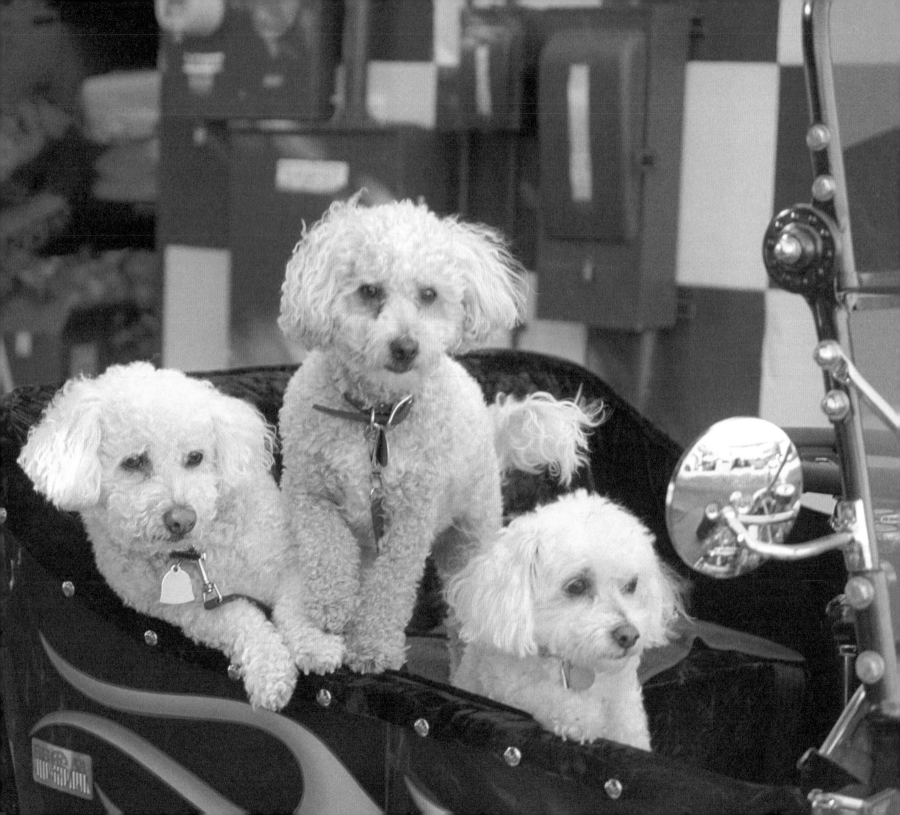

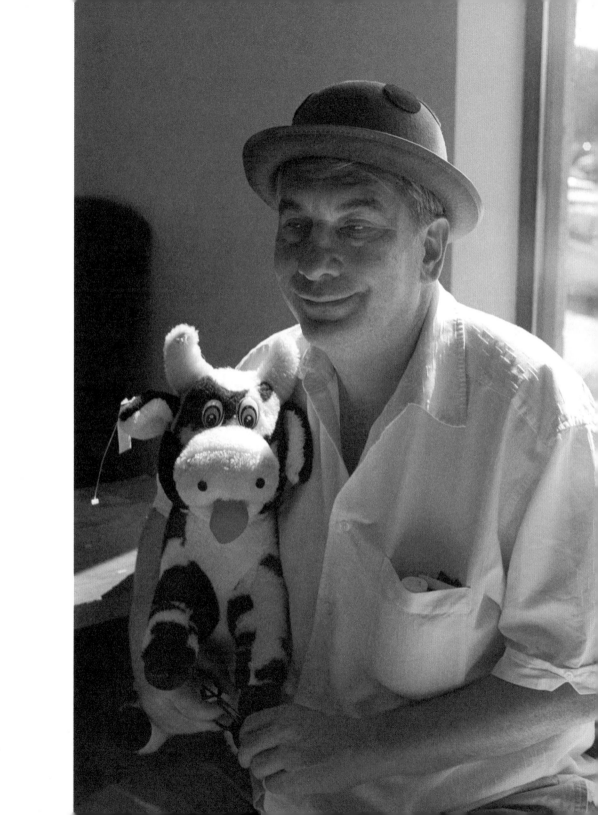

"For those who need another chance."

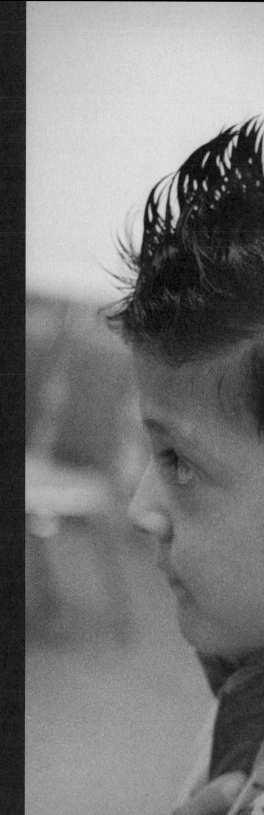

THAT HAS ALWAYS BEEN the motto of the Saint Paul
City Church. A large number of worshippers have been
homeless or drug addicted or spent time in prison.

While I was photographing, one congregation member
with a "Have I Sinned" tattoo on his neck was getting
ready to do a reading. He said he'd been in jail during
lockdown, strung out on methamphetamine, when he
found God. Now he serves as a deacon and sometimes
preaches from the pulpit.

"It was like a wind running across my face," he
remembered. "I heard the voice of the Lord say,
'Go tell them about Me.'"

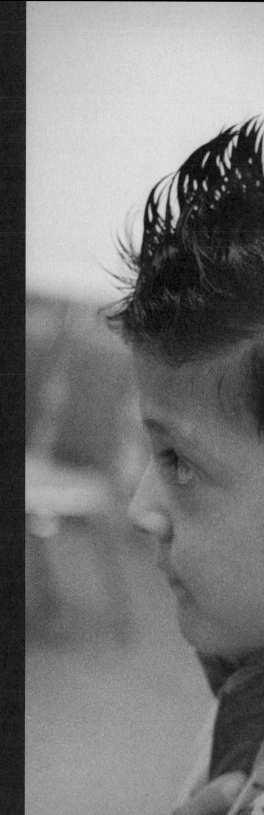

96

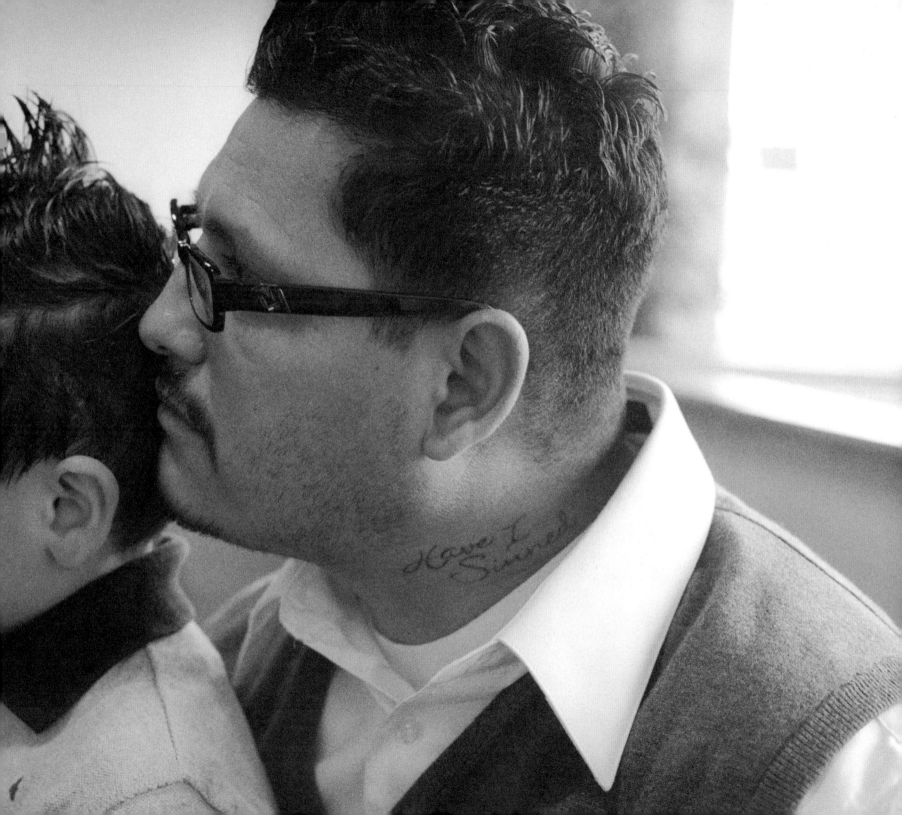

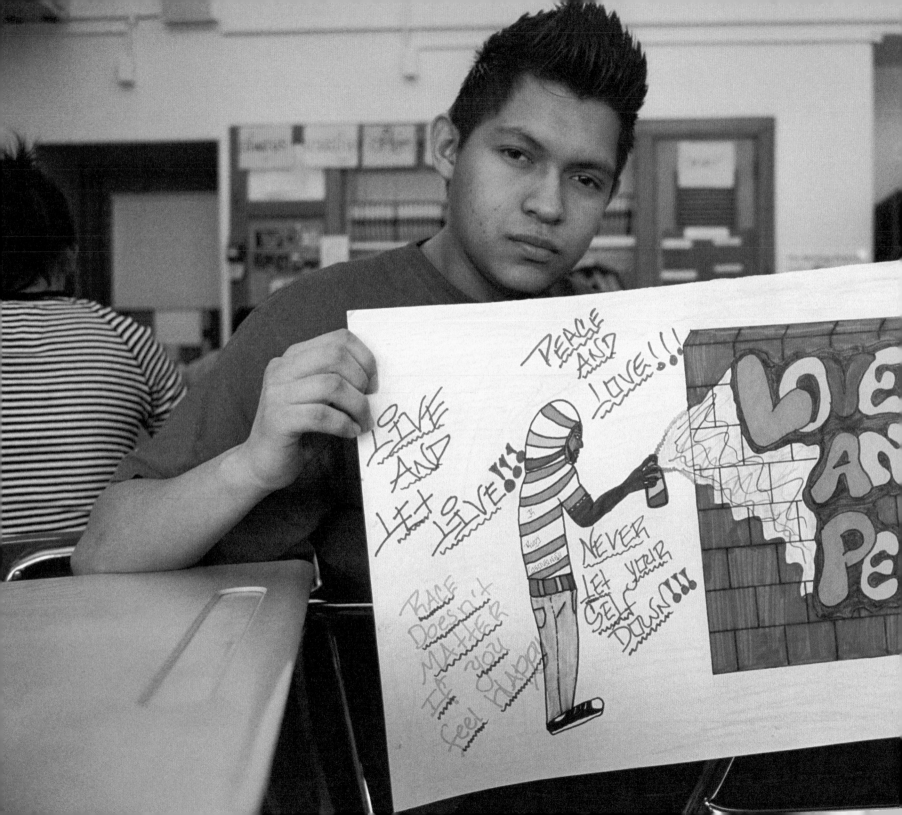

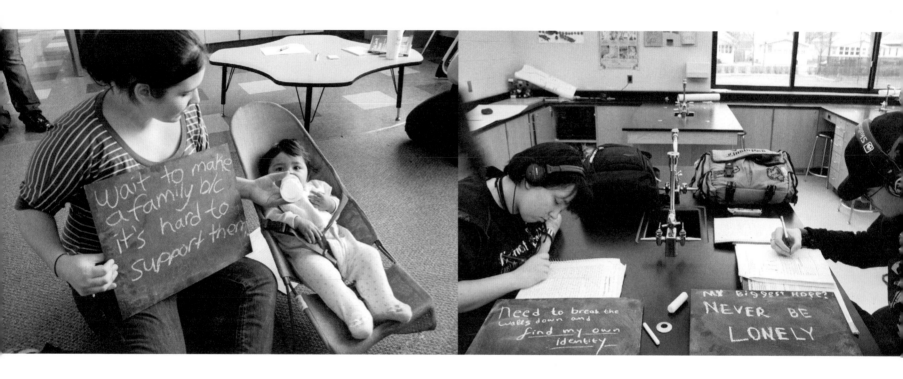

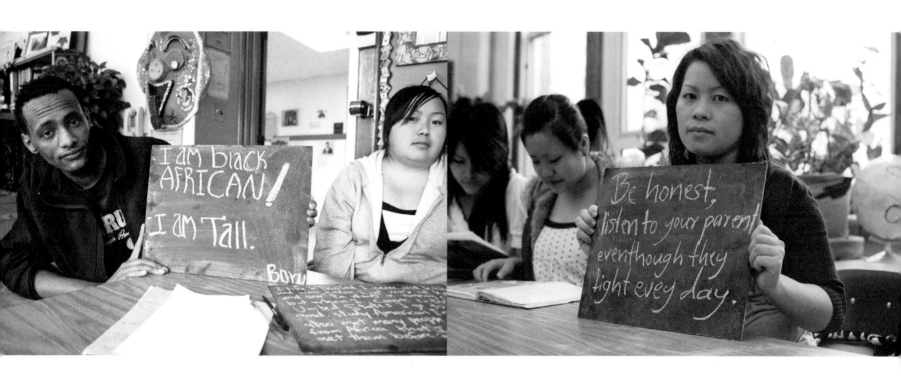

101

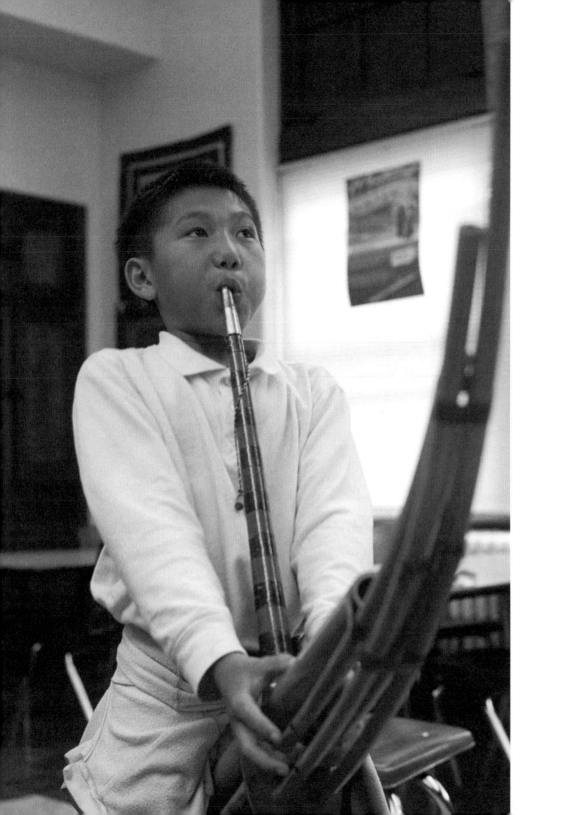

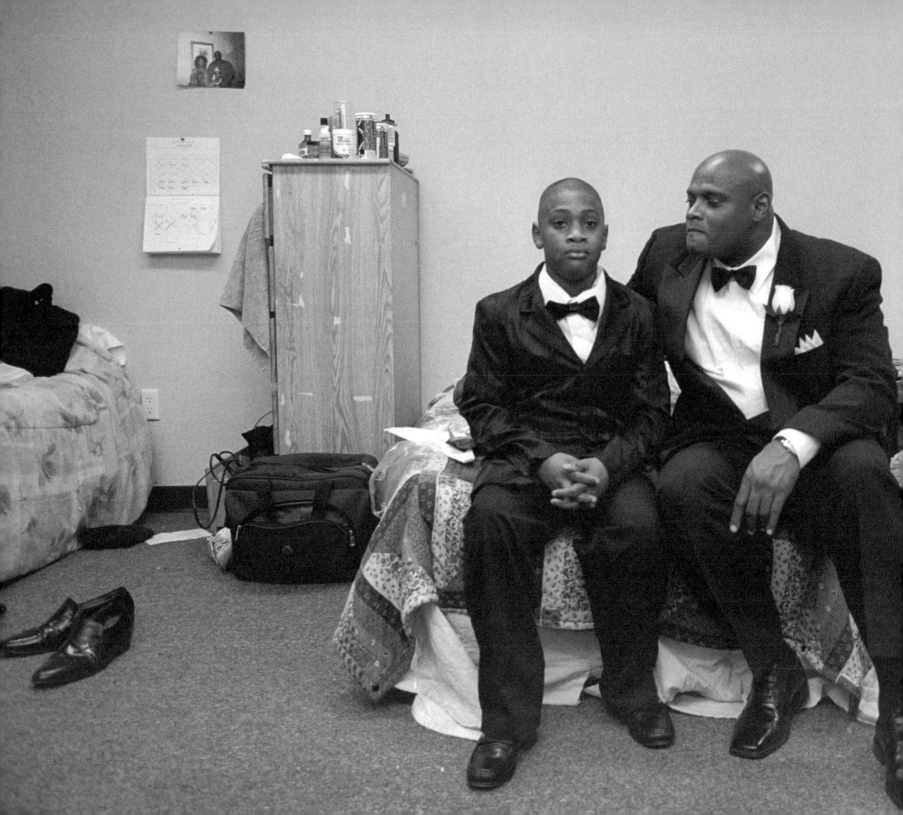

IT WAS BRUTALLY COLD. I drove around the block a couple of times debating whether to get out of my warm car. But some things you just can't pass up.

He shook his head and muttered when he saw me coming. I felt that familiar tinge of disappointment, sure he'd never let me take his portrait. As I got closer, I realized he was talking to someone on a wireless headset.

"They call me Captain Caveman, because of my deep voice, I guess," he said when he got off the phone. "I'm out here eight hours a day, seven days a week during tax season." It was his second year as a waver for Liberty Tax. "I've got on long johns, pajama tops, pajama bottoms, a snowsuit, blue jeans, and a hoodie. I feel fine." There was a bit of pride in his voice when he told me that fifty-one people before him had quit because of the cold.

During the holidays he makes his living as a Salvation Army bell ringer. In the summer he sells corn dogs out of a truck stand.

"I feel trapped when I'm in a building." He was vague when I asked why, but eventually admitted that being a Vietnam vet probably had something to do with it.

"I'm all for freedom and making people laugh," he said. "I love this job. Basically I'm an ass, but when I put on this outfit, I feel like I'm representing something."

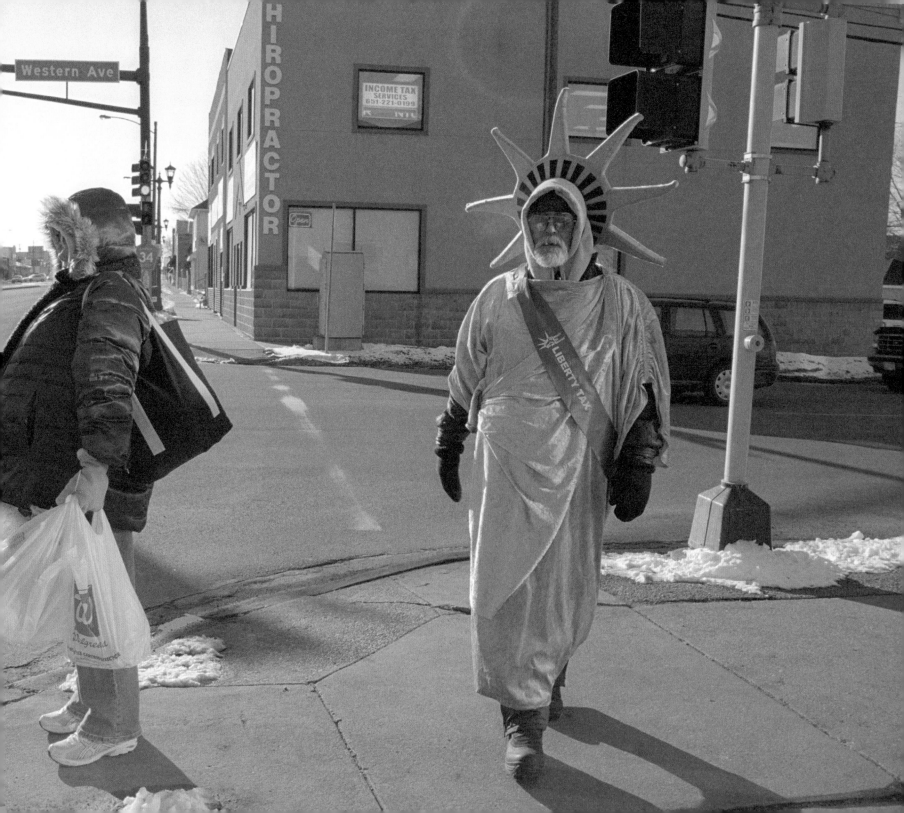

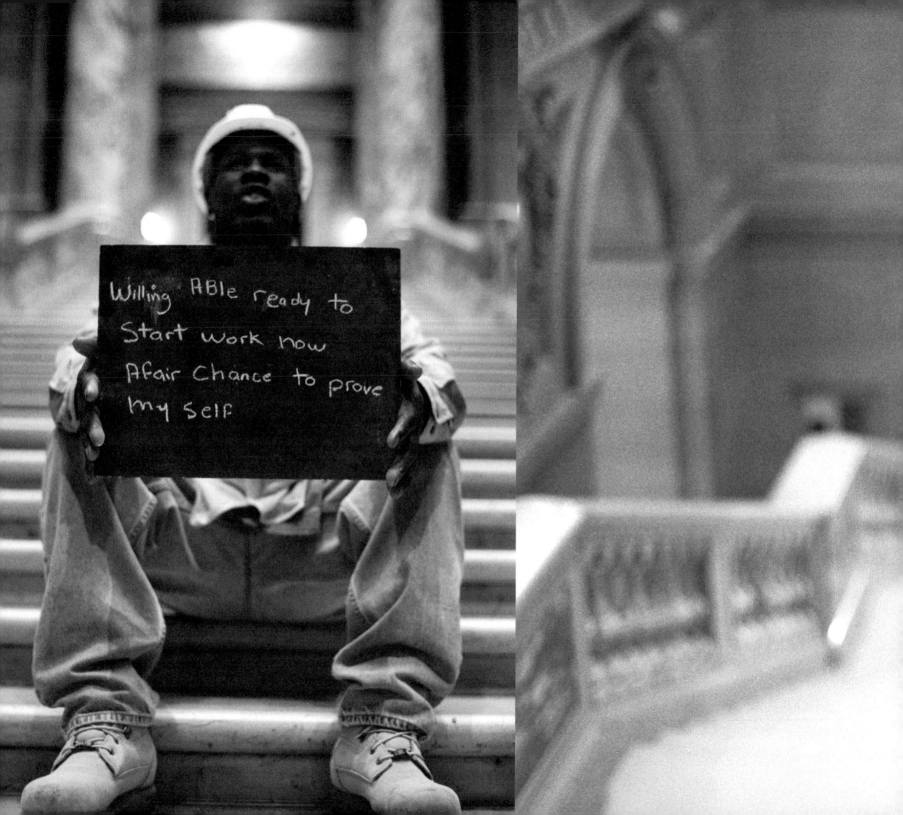

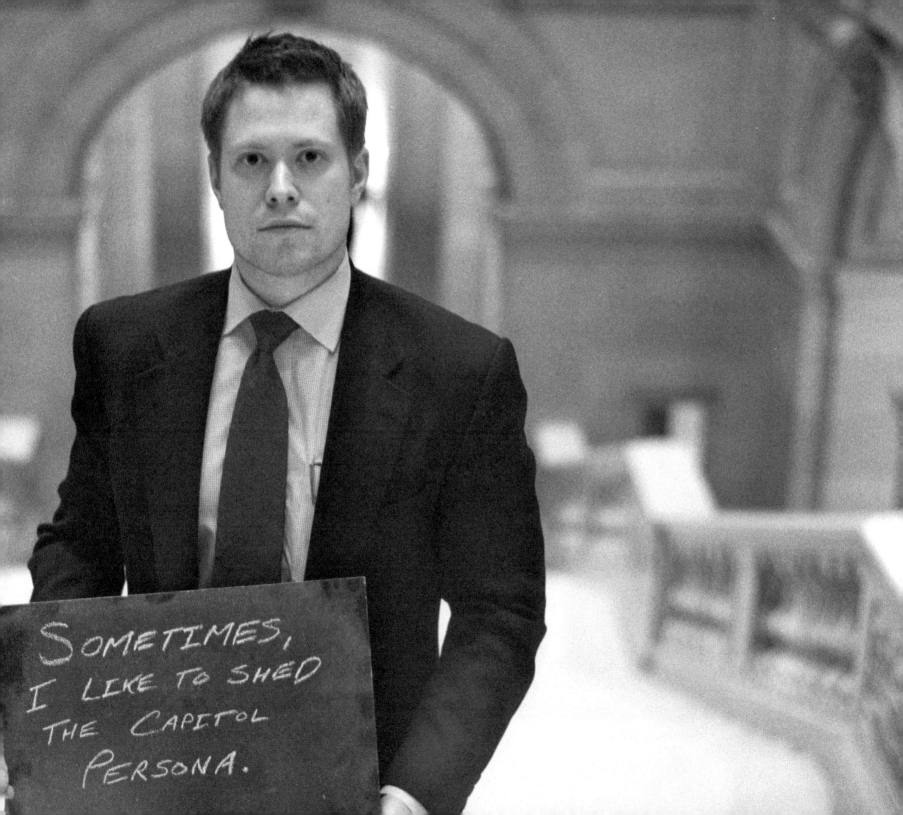

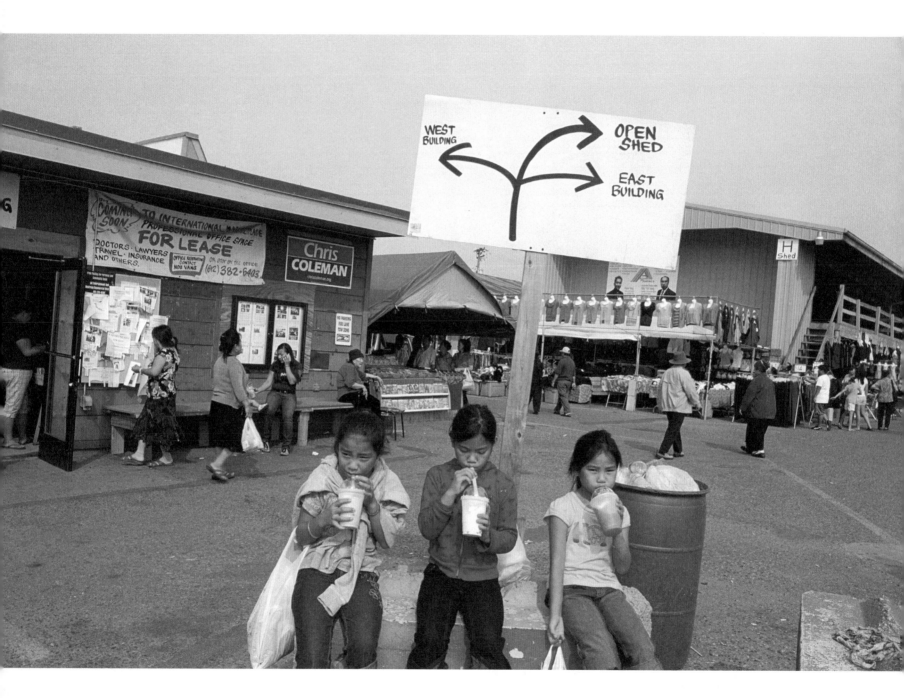

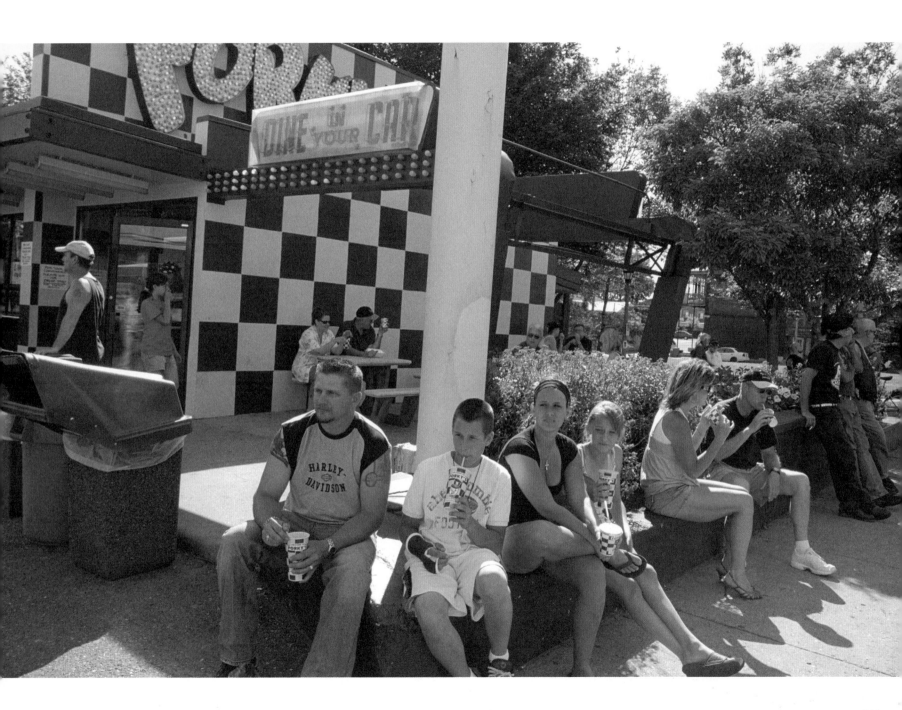

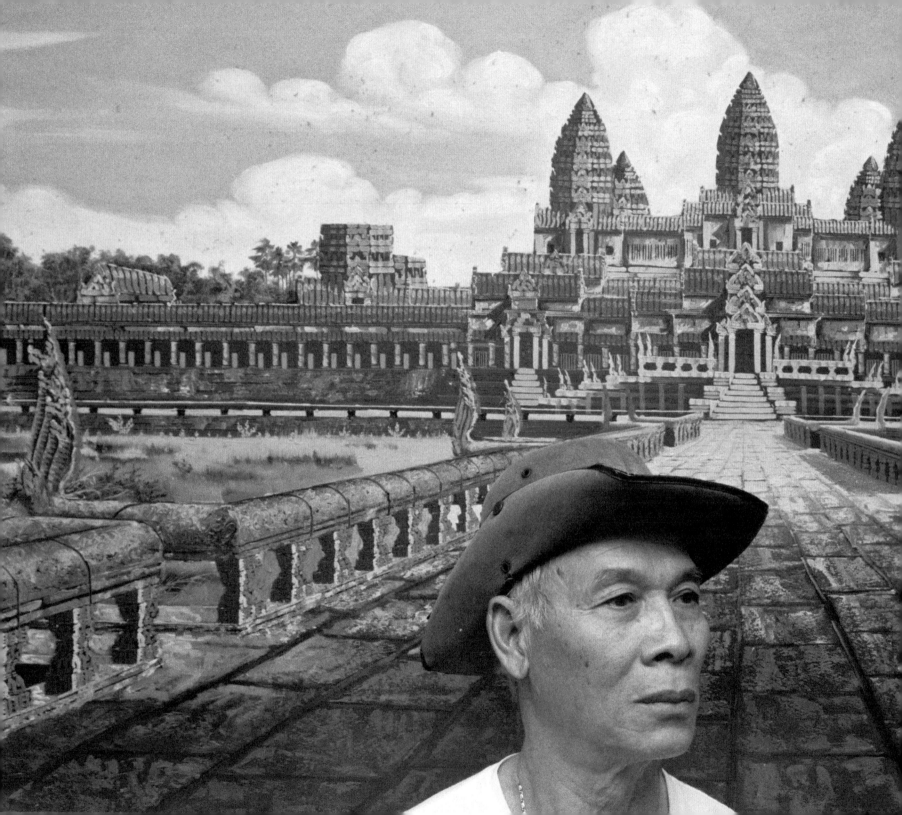

HE SURVIVED one of the worst atrocities in modern history. The Killing Fields of Cambodia claimed two hundred members of his large extended family, including his infant son. Out of the four hundred families in his village, only seven survived. For an hour as we sat in the restaurant owned by his daughter, he calmly spoke about what had happened years before. A mural of Angkor Wat, the most famous symbol of Cambodia, dominated the modest dining room.

With the hum of the restaurant as a backdrop, he told me his story: Khmer Rouge soldiers had ordered his village to evacuate with little food and no belongings. He and his wife and three children walked from morning to midnight. For two months they marched through the jungle, holding each other up, as they were herded to a destination they didn't know.

One morning they awoke to the smell of death and saw hundreds of bodies flattened by tanks. When they at last reached a camp, they worked in the fields from five o'clock in the morning until six o'clock in the evening. Sometimes, when the moon was full, they worked at night. Anyone caught not working was killed.

His daughter, visibly pregnant, joined us at our table during a lull in her work. "They whipped me," she said. "If you didn't know how to plant the rice correctly, they would make you stand in the red ant hill." She lifted a pant leg to show me the old scars.

His job was to take care of more than one hundred water buffalos. He counted them incessantly throughout the day and "in my dreams." If even one were lost, his family would have been killed. He gave each one a name and memorized every animal's face. He even knew their hoof-prints. He spent three years, eight months, and twenty days in the Killing Fields.

He wore the same white shirt, full of holes, for all that time. Inside in the folds of the cloth where no one could see, he had written the names and addresses of friends and relatives in France, Japan, and the United States. When he and his family escaped to a refugee camp in Thailand, he had everything he needed, inside his shirt. When he finally arrived in America, his wife threw it away. He wishes he still had it.

113

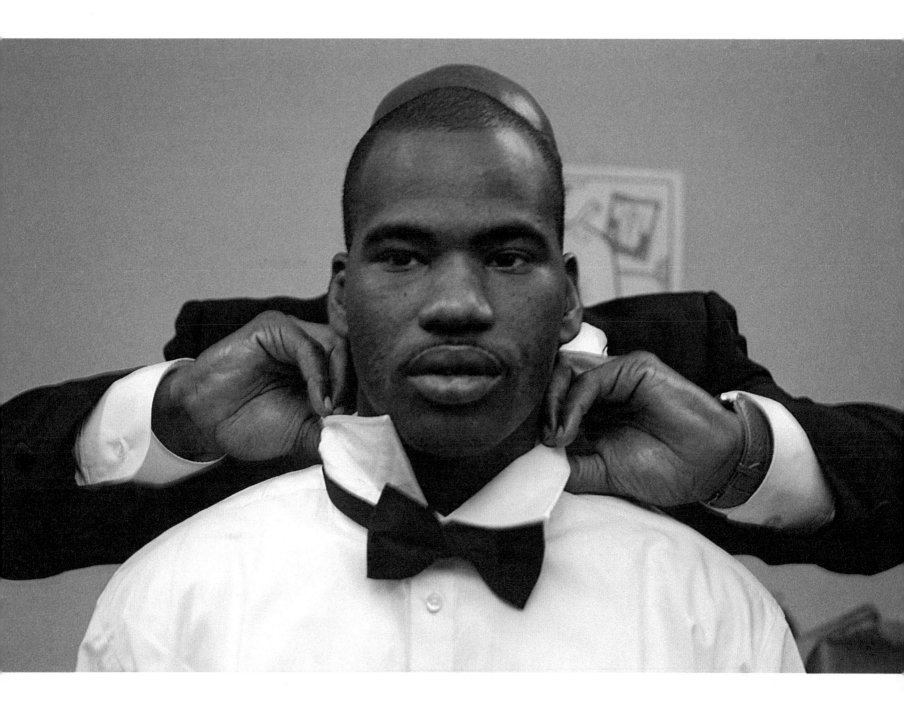

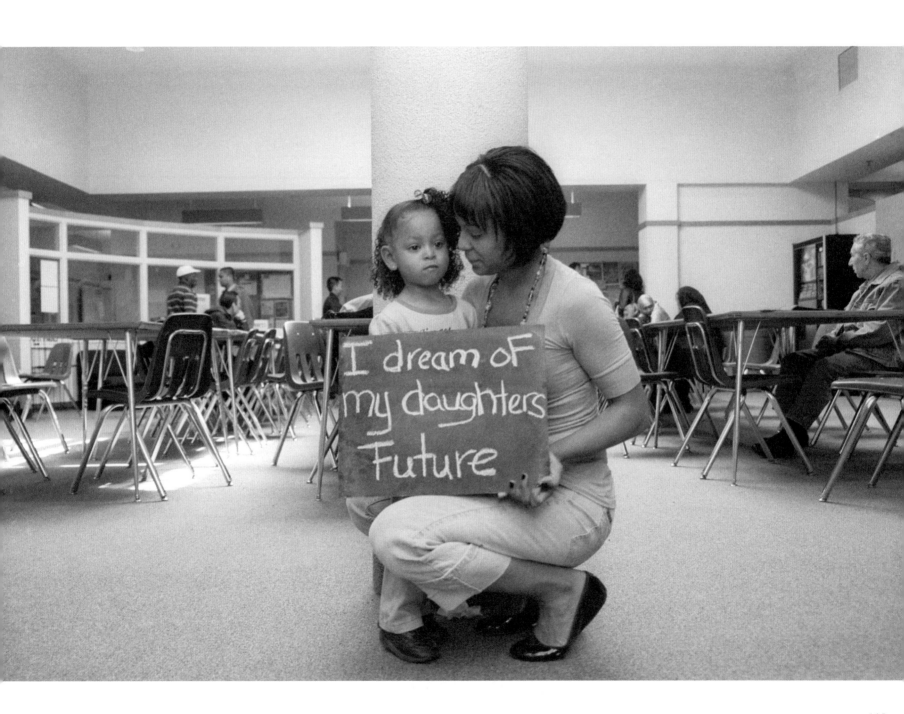

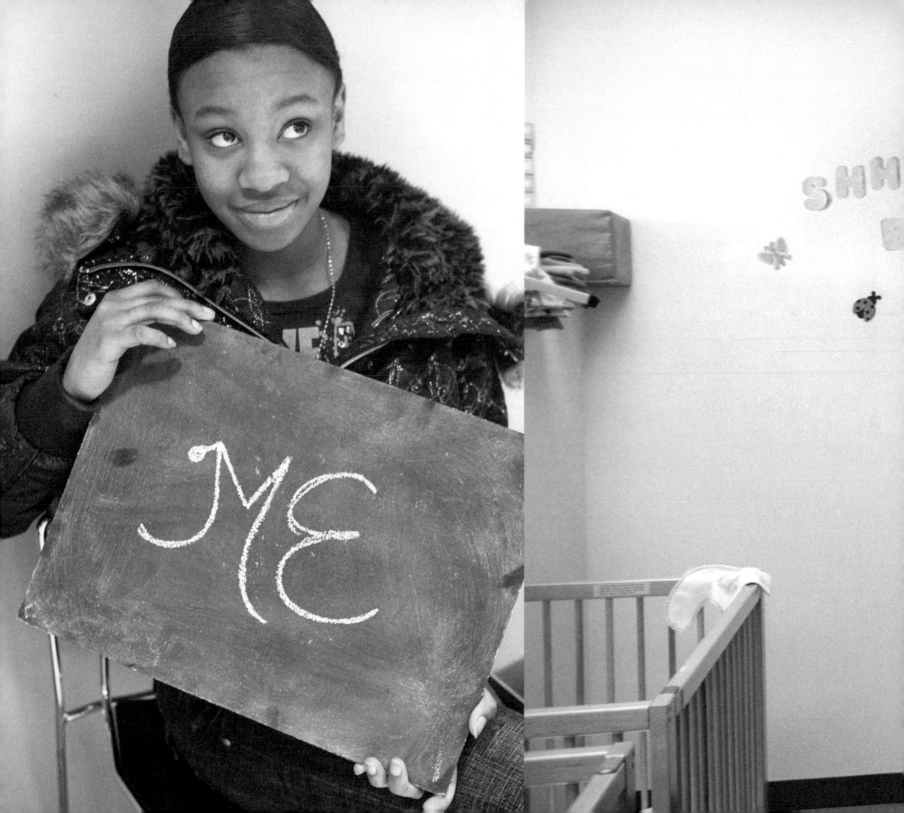

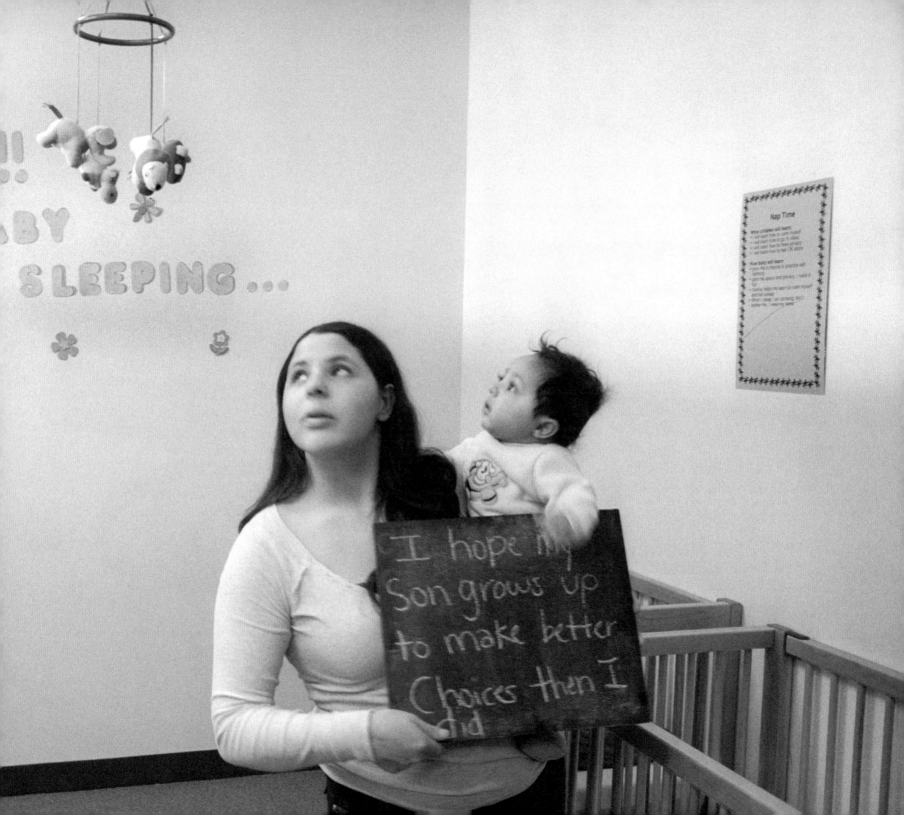

118

HE HAD BEEN AN ENGINEER in China making good money. Now he was in St. Paul looking for work. Anything, he said, even washing dishes.

We met at the Hubbs Center where he was learning English. I wanted to ask if I could photograph him for *The University Avenue Project,* but it was difficult. My Chinese was worse than his English.

So I called my older brother to translate. Unfortunately the engineer only spoke Mandarin, and my brother speaks only Cantonese. My brother's wife knew some Mandarin but didn't think it was good enough. So she enlisted her recently arrived daughter-in-law from China.

With all my translators in place, I put my cell phone on speaker. First, I asked a question in English to my brother, who repeated it to his wife in Cantonese, who repeated it to the daughter-in-law in rusty Mandarin, who finally relayed it to the engineer. After several merry-go-rounds of this, he at last got the gist of why I wanted to take his picture. His only concern was how the Chinese government would react to having his photograph shown in a public exhibition.

My brother, an immigrant himself, laughed and told him not to worry. "You're not in a communist country anymore. You're in America."

Waiting for
A Lot of Things

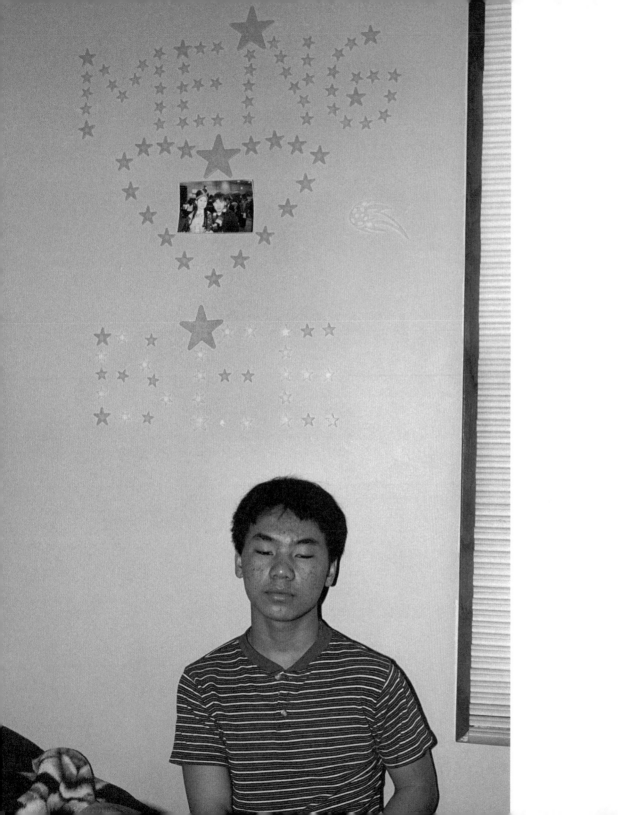

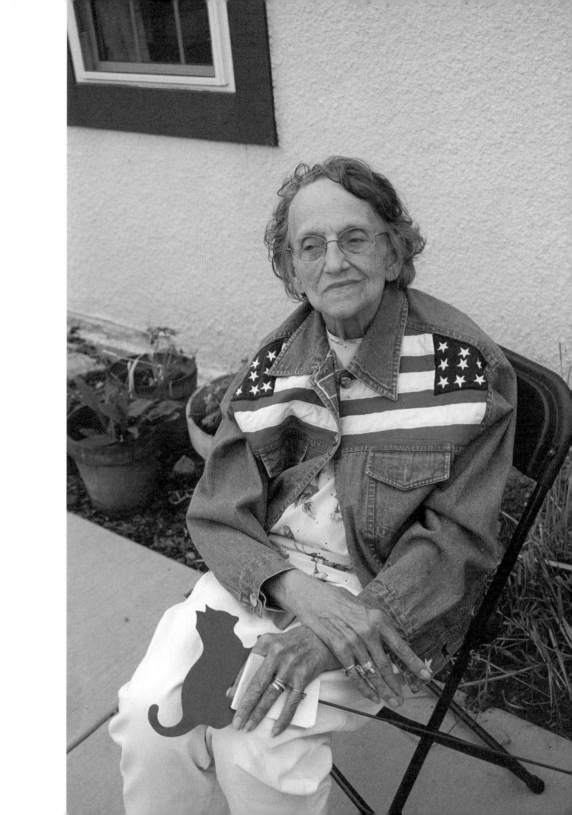

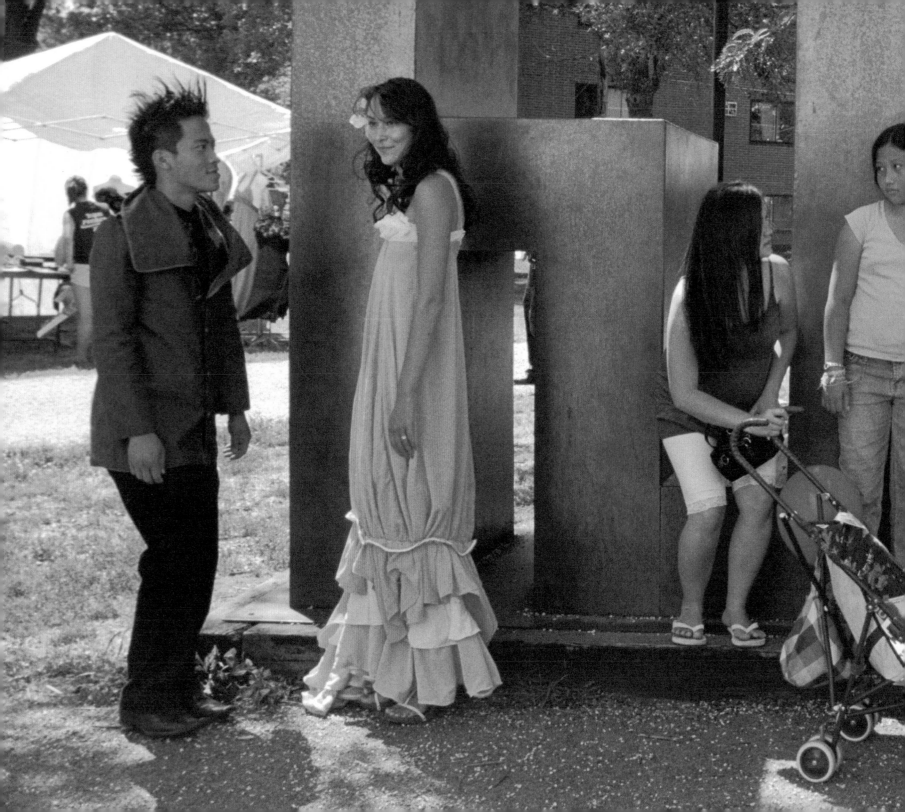

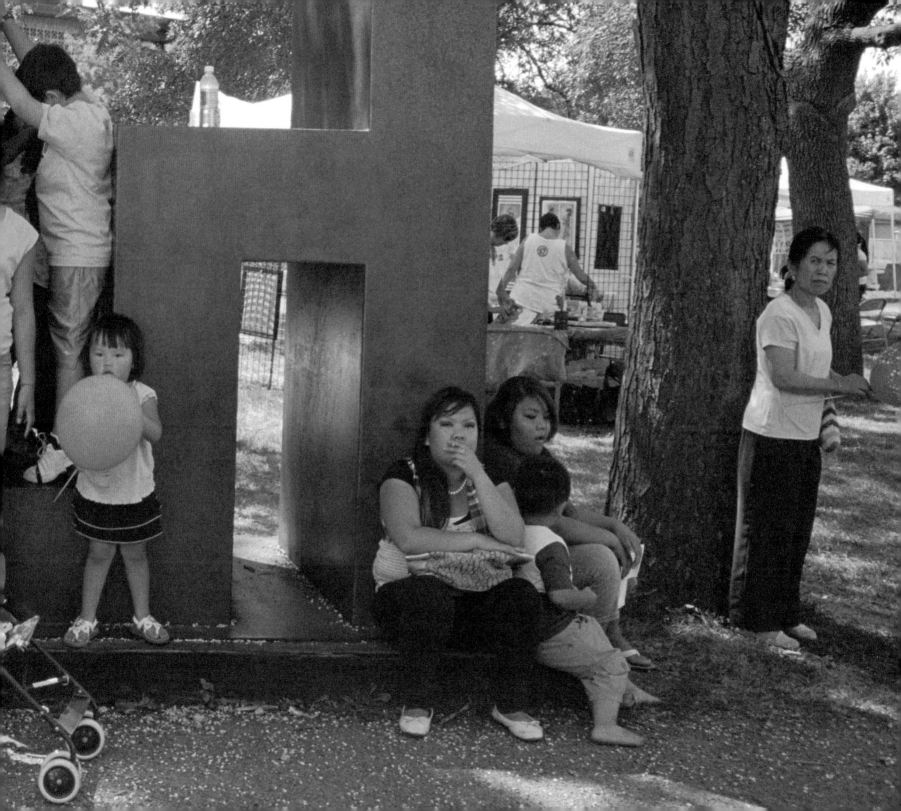

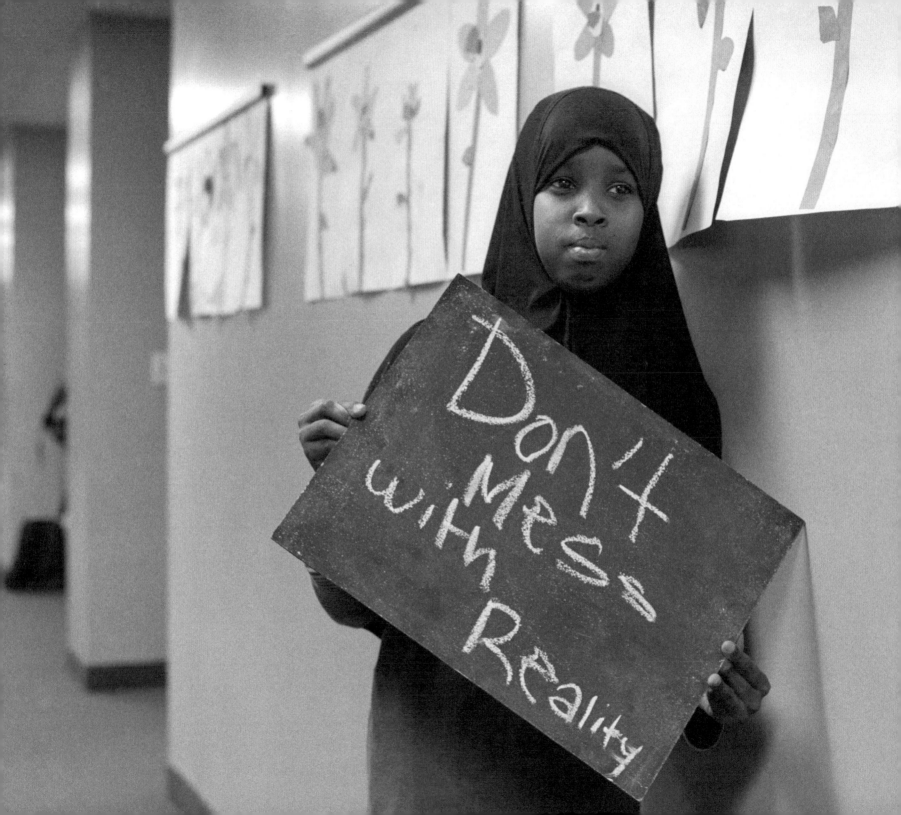

ON SEEING

I LIKE PHOTOGRAPHS that are real, a curious concept in the Photoshop era. Almost all of the images we see on a daily basis have little authenticity. They mostly serve to reinforce the status quo, driven by marketing and entertainment forces that fundamentally form our perceptions of each other, and ourselves.

I think good photographs are also organic: the meaning changes as the viewer does. The best photos suggest complex ambiguities of life, allowing space for interpretation.

Interpretations can be diverse. During *Lake Street USA,* for example, one person thought the photographs were about people who had died on the street. Another heard that the photographer had died, and the exhibition was a kind of memorial. Two teenagers speculated that it must be a "Nike thing."

Interpretations and reactions to *The University Avenue Project* will doubtless be just as varied. In the end, it is up to whoever is looking to decide what this exhibition is all about. What I'm trying to do is hold up a mirror—for the Avenue and the world beyond.

Credits and Acknowledgments, Volume One

Wing Young Huie, Artist

Public Art Saint Paul, Producer
Christine Podas-Larson
Ashley Hanson
Nic Hager
Abe Gleeson
Mitch Anderson

Marketing and Public Relations
Fast Horse
 Jörg Pierach
 John Reinan

Project(ion) Site Program and Design
Northern Lights.mn
 Steve Dietz
 Jeffrey Scherer
Meyer, Scherer & Rockcastle, LTD (MS&R)
 Matthew Kruntorad
 Kristilyn Vercruysse
Courtney Kruntorad, cm.k design
Frank Frattalone, Frattalone Companies
Brad Oren, DART Transfer and Storage, Inc.

Publication
Minnesota Historical Society Press
 Pamela McClanahan
 Daniel Leary
 Shannon Pennefeather
 Mary Poggione
 Alison Aten
 Gwenyth Swain, freelance editor

Photograph Production
Jerry Mathiason

Music Curators
Dr. Allison Adrian, St. Catherine University
Jade Tittle, Tinderbox Music and 89.3 The Current

Identity and Book Design
Aaron Pollock

Website Engineering
Steve Appelhans
Dan Gustafson, BAI Solutions

Education Consultants
Todd Richter, Roseville Area Middle School
Mary Dorow, Saint Paul Public Schools

Volunteer Coordination
Ann Bellows
Louise Jones

Community Partners
Peggy Lynch, Friends of the Parks and Trails of St. Paul
 and Ramsey County
Brian McMahon, University UNITED
Linda Winsor, University Avenue Business Association
Lori Fritts, Midway Chamber of Commerce
Michael Jon Olson, Hamline Midway Coalition
Dan McGrath, Take Action Minnesota
Western Bank
 William Sands
 John Bennett
Steve Wellington, Wellington Management, Inc.
Jim Miller, James Miller Investment Realty Co.
Jim Ibister, Saint Paul RiverCentre
Patrick Seeb, Saint Paul Riverfront Corporation

Interns
Emily Cox, Macalester College
Sarah King, University of Saint Thomas
Coreana Fairbanks, Minneapolis College of Art & Design
Dayna Besser, College of Visual Arts

Special Thanks To
Public Art Saint Paul Board of Directors
 Edward F. Fox, Board Chair
 Craig Amundsen
 Sue Banovetz
 Bob Bierscheid
 Zachary Crain
 Tom Eggum
 John Fedie
 James Garrett, Jr.
 David King
 Peter Kramer
 Finette Magnuson
 Joan Palm
 Marilyn Porter
 Susan Price
 Andrea Stimmel
 Imogene Treichel
 Yamy Vang
 Mark Wickstrom
 Ramsey County Commissioner Toni Carter, Ex Officio
 Minnesota State Representative Cy Thao, Ex Officio

City of Saint Paul
Mayor Chris Coleman
Housing and Redevelopment Authority
 Councilmembers Melvin Carter III and Russ Stark
Department of Public Works
 Bruce Beese
 Shannon Tyree

Participating Schools
Hubbs Center for Lifelong Learning
Creative Arts High School
Gordon Parks High School
International Academy–LEAP
AGAPE High School
Avalon School
New Spirit School
Dugsi Academy

Sponsors
The University Avenue Project is presented by Public
Art Saint Paul with major support from a Joyce Award
of the Joyce Foundation, a publication grant from the
Elmer L. and Eleanor J. Andersen Fund of the Minnesota
Historical Society, funding from The Saint Paul Founda-
tion, F. R. Bigelow Foundation, Travelers Foundation,
Huss Foundation, Hardenbergh Foundation, Mardag
Foundation, Katherine B. Andersen Fund, George Mairs,
Bruce A. Lilly, Kent and Ariel Dickerman and Dicker-
man family members, and in-kind support from the 3M
Foundation, Fast Horse, Meyer, Scherer & Rockcastle, LTD
(MS&R), Frattalone Companies, and the Pioneer Press/
TwinCities.com.

Author/Artist Notes
In my work photographing church congregations,
I am indebted to Dr. Allison Adrian, music professor
at St. Catherine University, with whom I have collabo-
rated. Her dissertation, which focused on non-English
Lutheran music, was titled: "A Mighty Fortress Far
from Lake Wobegon."

The Minnesota Historical Society Press is a member of
the Association of American University Presses.

Manufactured in the United States of America

10 9 8 7 6 5 4 3 2 1

∞ The paper used in this publication meets the mini-
mum requirements of the American National Standard
for Information Sciences—Permanence for Printed
Library Materials, ANSI Z39.48–1984.

Design by Aaron Pollock
Composition by Daniel Leary & Phoenix Type
Printed by Print Craft, Inc.

Mixed Sources
Product group from well-managed
forests and other controlled sources
www.fsc.org Cert no. SW-COC-002374
© 1996 Forest Stewardship Council
FSC

International Standard Book Number
ISBN 13: 978-0-87351-782-9 (paper)

Library of Congress Cataloging-in-Publication Data

Huie, Wing Young, 1955–

 The University Avenue Project : the language of urban-
ism : a six-mile photographic inquiry / Wing Young Huie.

 p. cm.

 ISBN 978-0-87351-782-9 (paper : alk. paper)

 1. University Avenue Project (Saint Paul, Minn.)
2. City and town life—Minnesota—Saint Paul—Picto-
rial works—Exhibitions. 3. Street life—Minnesota—
Saint Paul—Pictorial works—Exhibitions. 4. Cultural
pluralism—Minnesota—Saint Paul—Pictorial works—
Exhibitions. 5. Photography—Social aspects—Min-
nesota—Saint Paul—Exhibitions. 6. University Avenue
(Saint Paul, Minn.)—Pictorial works—Exhibitions.
7. Saint Paul (Minn.)—Biography—Pictorial works—
Exhibitions. 8. Saint Paul (Minn.)—Social life and
customs—Pictorial works—Exhibitions. 9. Saint Paul
(Minn.)—Social conditions—Pictorial works—Exhibi-
tions. I. Title.

F614.S4 H86 2010 977.6'581—dc22 2010008722

The University Avenue Project, Volume 2, available in
August 2010, will document additional images and
stories from along the avenue as well as the reactions to
and interactions with the public exhibit ($12.95, paper,
128 pages, ISBN: 978-087351-794-2).